comic artist's photo reference

People and Poses

Buddy Scalera

IMPACT
Cincinnati, Ohio
www.impact-books.com

F+W PUBLICATIONS, INC.

10 09 08 07 5 4 3

Distributed in Canada by Fraser Direct
100 Armstrong Avenue
Georgetown, ON, Canada L7G 5S4
Tel: (905) 877-4411

Distributed in the U.K. and Europe by David & Charles
Brunel House, Newton Abbot, Devon, TQ12 4PU, England
Tel: (+44) 1626 323200, Fax: (+44) 1626 323319
Email: mail@davidandcharles.co.uk

Distributed in Australia by Capricorn Link
P.O. Box 704, S. Windsor NSW, 2756 Australia
Tel: (02) 4577-3555

Library of Congress Cataloging in Publication Data
Scalera, Buddy
 Comic artist's photo reference : people and poses / Buddy Scalera.
 p. cm.
 ISBN-13: 978-1-58180-758-5 (pbk. : alk. paper)
 ISBN-10: 1-58180-758-9 (pbk. : alk. paper)
 1. Human beings--Caricatures and cartoons. 2. Comic books, strips, etc.--Technique. 3. Drawing from photographs--
Technique. I. Title.
 NC1764.8.H84S32 2006
 741.5--dc22

 2005029145

Photographer: Buddy Scalera
Photography Assistant and Lighting Supervisor: Karyn DeMarco
Cover Art: Matt Haley
Editor: Amy Jeynes
Designer: Guy Kelly
Page Layout: Dragonfly Graphics LLC
Production Coordinators: Mark Griffin and Matt Wagner

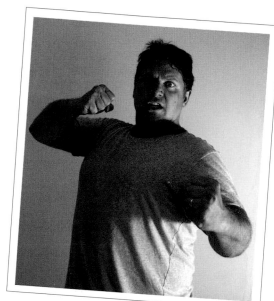

Photo by Karyn DeMarco

about the author

Buddy Scalera is a writer, editor and photographer. He is known for his bestselling series of photography CD-ROMs, *Visual Reference for Comic Artists*, and for his writing work on Marvel Comics' *Deadpool*, *Agent X* and *X-Men Unlimited*. He has written and self-published several comic books, including *Necrotic: Dead Flesh on a Living Body* and *7 Days to Fame*, a comic book miniseries about a reality show on which contestants commit suicide in exchange for fame. Buddy was the creator and editor of Wizard Entertainment's WizardWorld and Wizard-School websites. He continues to work as a web and multimedia developer in the entertainment industry. Visit his website, www.buddyscalera.com.

dedications

To Janet: Thank you for your endless love and patience. I have only one picture in my head, and it is of you.

To Danielle and Nicole: Follow your dreams and never fear failure. Never give up. And no matter what, you can always come home and we will love you unconditionally.

acknowledgments

Special super-duper thanks to Joe Valentino and Nelson Lopez of Shin Budo Karate Do of New Milford, New Jersey, for the studio space.

THANK YOU TO . . .

. . . Loukas, Norman, Haydee and Veronica, who spent hours under hot lights to make sure we got the shots.

. . . Liam Devine for your endless patience as I did test shots and edited pictures. Thanks, Irish.

. . . Karyn DeMarco for giving me that first digital camera.

. . . Paul Chadwick, Billy Tucci, Greg Land, Sean Chen, Matt Haley, Fernando Ruiz and Mitchell Breitweiser for doing these outstanding demos. I appreciate your time, effort and professionalism.

. . . Pam Wissman for giving me this tremendous opportunity. You're my new superhero.

. . . Guy Kelly for bringing a unique and exciting vision to the design.

. . . Amy Jeynes for making this a truly fun collaboration. What's next?

In Memoriam
Arlene Cosentino
1928–2003

Introduction 6

Table of Contents

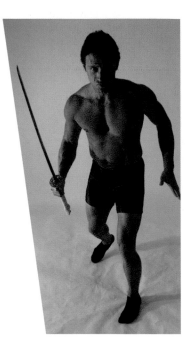

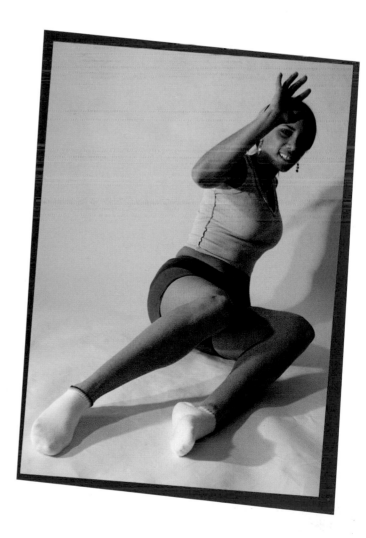

This . . . is a great book. It may be one of the top ten greatest books ever written in the canon of nonfiction since Gutenberg fired up that creaky old press.

Okay, maybe I'm exaggerating a *little*, but hey, that's comic books for you. It's not exactly known as the most subtle of mediums, so just, y'know . . . go with it. People fly, they have heat vision, and they wear spandex—all without feeling the least bit self-conscious.

But seriously, folks, this is a darn good book. When you flip through and see the people who have worked on it, including **Greg Land, Paul Chadwick, Matt Haley, William Tucci, Sean Chen, Fernando Ruiz, Mitchell Breitweiser**—and, of course, me—you may come to a similarly hyperbolic conclusion. I mean, really. Just go back and look at those names again. This isn't your average photo-reference book with lame-o lessons by wannabe artists. Every artist who contributed to this book has already "made it" in this business. (Except me. I'm mainly a comic book writer, if you can believe.)

If you're already a professional or almost-pro artist, you know what this book is and how it all works. It's a pose file. You need it. Just flip through a few pages. As you do, head over to the cash register and I'll give you the stats: four models, **500+ color photographs, seven art demos, and a CD-ROM with an additional 600 photos** that do not appear in the pages of this book.

If you are an aspiring pro or if you are buying this for an artist in your family, well, let me give you the 30-second pitch.

Creating comic books can be one of the most rewarding and desirable careers any human being could have. It's fun, it's fulfilling—and it's fun. You get paid to draw characters doing cool stuff like flying and blowing things up. It's **the one career that'll let you make big-budget Hollywood-esque movies without leaving your parents' basement.**

A career in comics beats being a doctor or an astronaut or even the person who pokes cigarette butts with that stick with a nail at the end. (You may think I am poking fun [pun intended] at those careers. I'm not. If smokers didn't throw cigarette butts on the ground, the world wouldn't need to employ cigarette-butt-people. They do provide a valuable public service, which is more than I can say for astronauts.)

You'd be a wise and well-respected person if you encouraged someone in your life to **pursue a highly lucrative career in comic book art.** Again, not joking. If you break in as a comic artist, you can do pretty well for yourself financially. (You can also do pretty lousy financially, but saying that won't help me sell books, which is my job.) And every time someone wins a big, prestigious comic book award, they need to thank someone, and that person might as well be you, right?

So you're probably thinking "If I buy this book for my loved one, **will he/she adore me forever and remember me when he/she is rich and famous?" The answer is an unequivocal "yes."** (Some restrictions apply. Here comes the fine print.) Drawing comics is a fine and fulfilling career. But it is also surprisingly difficult. It requires an endless amount of patience, dedication and practice to survive as a comic book artist. That's because drawing for money means that an artist must draw things that he or she probably would not try to draw otherwise. In fact, an artist who breaks in will be asked to draw three to five separate illustrations per page. Every workday.

Sound like a cool job? Yeah, it is. But remember, an artist works from a comic book script written by someone else, and many of those scripts aren't very good. In fact, I have written several embarrassingly bad comic book scripts myself and been paid for them. Seek them out. (Note: As a rule of thumb, comic book writers are paid on par with federal prisoners, who, at the time of this writing, earn $1.50 per hour for hard labor. I've been paid less than that for scripts.)

The point is that creating comic book art is much harder than it looks. You have to work fast and efficiently to create an attractive, professional product. You really have to THINK when you work. Your art can't just be attractive; it must tell a story. That is not as easy as it might seem.

I interviewed each contributing artist in this book about his art demo. Along with the soon-to-be-award-winning photos in this book, those demos are pretty amazing. **Even if you are the best artist of all your friends and even your mom says so, you should study these art demos.** In fact, I'd suggest you stop reading this introduction, since it's really not going to teach you anything.

Anyway, back to the topic of photo reference. Many (not all) top artists utilize photo reference to help them visualize key poses. And even though the human body is limited to a certain number of poses, there is an infinite number of ways to draw that figure. (Question for math people: Is there really an infinite number? Or did I just make up a stat that will be disproven by some kid with an abacus?)

Professional artists need to draw characters running, jumping, kicking, punching, wrestling, smoking, drinking and just about every other action verb you can think of. If it's possible . . . or hey, even impossible . . . comic artists will have to draw it. This book and its companion CD-ROM contain all of those poses from a variety of angles. This is a functional reference book that will never go out of date unless we humans evolve anatomically.

The best artists are masters of the illustrated figure and know just how to manipulate the angle, exaggerate the foreshortening and pump up the intensity for the proper effect. Many professional artists achieve this by knowing how and when to use photo reference.

Okay, so I am finally getting to my point here. If you are an aspiring pro or you have one in your family, you're going to need photo reference. And unless your family looks like the four models in this book, you should buy a copy. Not only because it will make me fabulously rich, and it will, but because it will help that person go on to a career in comic books.

And when your comic book artist steps out of a white limo at a gala black-tie event at which they are about to accept a shiny, gold-plated award, they will wave to you. You'll know that you helped launch that career by buying this book, and you will put down that cigarette-butt stick and wave back with pride.

Or, if you're an astronaut, you can wave, too, but nobody will see you.

Buy this book. Someone needs it.

Buddy Scalera
buddy@buddyscalera.com

How to Use Photo Reference

BY SEAN CHEN

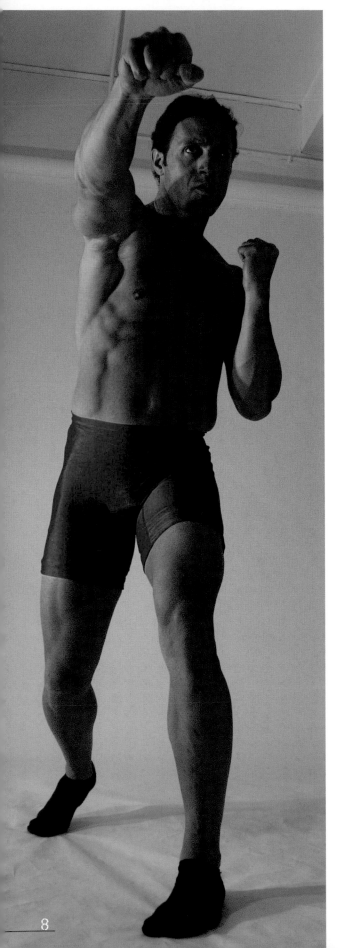

You'd think that looking at photo reference would be a simple and straightforward process. But it just isn't. Photographs and comic book pages are two-dimensional representations of three-dimensional objects.

An experienced artist can trick the viewer into seeing 3-D people, places or things by leveraging art techniques such as foreshortening, shading and perspective. A good photograph can help you add weight, depth and realism to your illustrations. But first, you need to know how to look beyond the flat image of the photo to see form and motion.

Find Your Photo

Look for a photo that gives you the pose you need to tell your story. There are only so many ways that the body can move and twist, but there are infinite ways to draw it. As an artist, you can move your mental "camera" in any possible angle to create a new, fresh and exciting illustration. Choose a photograph that closely approximates the picture you want to draw. It may not match perfectly, but as an artist you can borrow gestures and expressions from other photographs or something that you envision in your head.

This photograph shows a tall, physically powerful man throwing a punch. The low angle of the shot makes him seem even taller and more imposing.

From an emotional standpoint, a reference photo with two light sources adds drama, depth and feeling to the figure.

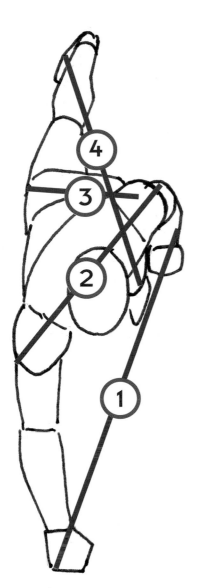

Understand Three-Dimensional Space

The model in this photo exists in the real world, in 3-D space. But the photograph shows only a 2-D representation of this person. Our minds allow us to use visual cues to perceive depth and distance in a flat image.

Try to move the mental camera I mentioned in step 1 to a vantage point directly above the figure, and draw what the model is doing in the 3-D space. This will allow you to see how the body is moving in the real world. You can see that this model's body is moving forward while one of the legs remains firmly behind. Most of his body weight is on the left leg. All the other body parts fan out from this point. When the figure is standing at rest, it is completely balanced. When the body begins to move, there is a new dynamic as the figure stretches and expands in the 3-D plane. The figure in this position is out of balance. One side is compressed and bears most of the weight. The other side is delivering energy by pushing weight into a punch. Notice how the punch leads the body with forward momentum. It looks almost like a spiral staircase, which gives you a sense of how this shape exists in the real world. These are important details that will make your final drawing breathe with depth, weight and motion.

1 The fist is the part of the body that has travelled farthest from its original position.

2 The head and shoulders lead the torso. Because of the outstretched arm, the shoulders are angled from their original position. Notice how the angle differs from that of the hips.

3 The hips remain straight and close to their starting position. In the starting position, the hips bear the body's weight, but here the weight has shifted to the model's left upper thigh and left knee.

4 The model's right foot remains in its original position. It anchors the figure and gives him something to push and launch against. If this model were standing on ice, he would not have the power and thrust shown in this pose.

Ultimately this is a body out of balance. This pose suggests a figure in motion and delivering energy, which is something that comic artists must be able to draw.

throw off the balance

The natural, at-rest state of the body is standing up straight (near right). That's when the body is most balanced. Running and punching (far right) put the body out of balance. In comics, the action will often make the body look like it's about to tip over. Use this to your advantage to heighten the sense of motion.

These figures are approximately the same height, weight and body type, but notice the subtle visual cues that tell the reader that the body on the far right is in motion. Notice also how the pose on the near right is very relaxed, compared to the picture on the far right. Both are effective poses that convey different messages to the reader.

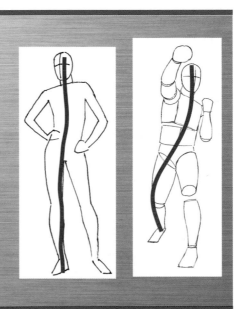

Break Down the Body Into Sections

Every part of the body has weight and volume. Start your drawing by sketching the figure with simple lines. When you draw the hips and shoulders, imagine the 3-D space. Notice how the body torques and spirals, just as we discussed in step 2. Look for other anatomy clues, such as the way the back leg and the hip pivot together. The hip and the leg can bend and move, but the anatomy and mechanics will stay relatively consistent in all figures. That is, there are only so many ways the leg can move within the bone structure of the hip.

Imagine each body part to be a cylinder stacked on top of another cylinder, then draw the cylinders.

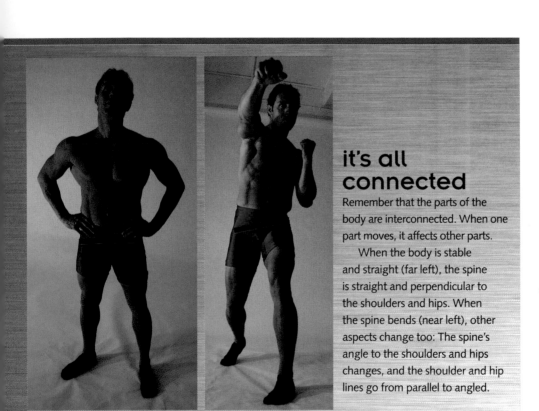

it's all connected

Remember that the parts of the body are interconnected. When one part moves, it affects other parts.

When the body is stable and straight (far left), the spine is straight and perpendicular to the shoulders and hips. When the spine bends (near left), other aspects change too: The spine's angle to the shoulders and hips changes, and the shoulder and hip lines go from parallel to angled.

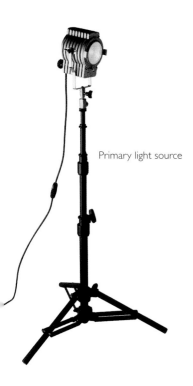

Primary light source

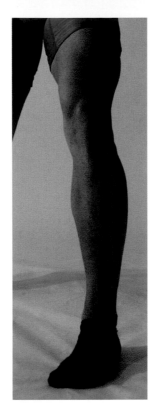

Secondary, weaker light source

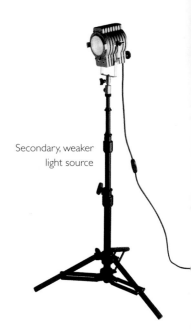

Add Shading

Two light sources reveal the contours and volume of the figure in this photo. The bones add structure, but the musculature creates complex shadows. You can figure out about 70 percent of the shadows from just knowing the direction of the light. But to get the core tonality right, you must analyze the peaks and valleys created by the muscles. Remember, also, that bones are not perfectly straight. Use a ruler to reveal the natural curve of the bone, and use this knowledge to create a more realistic shadow.

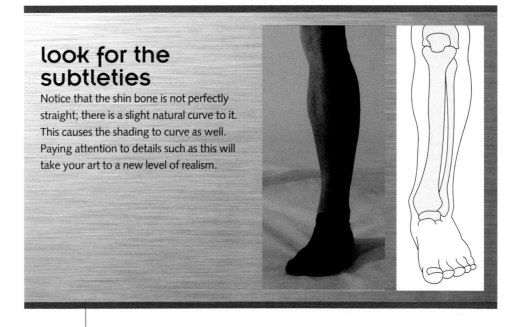

look for the subtleties

Notice that the shin bone is not perfectly straight; there is a slight natural curve to it. This causes the shading to curve as well. Paying attention to details such as this will take your art to a new level of realism.

Norman
African-American Male

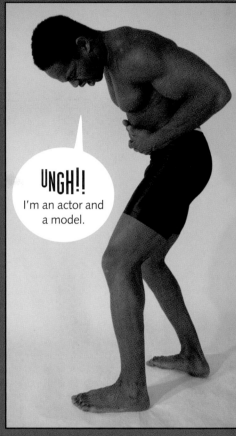

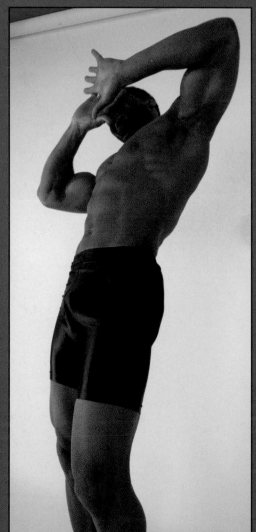

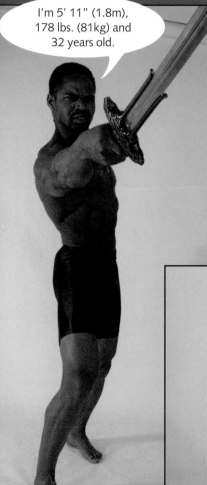

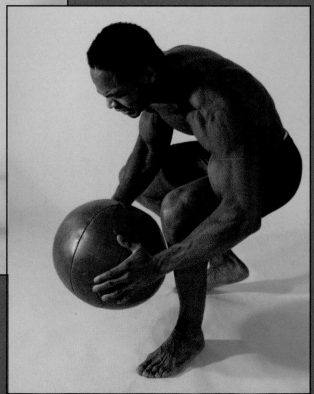

E-mail me at
webmaster@kellyman.4t.com

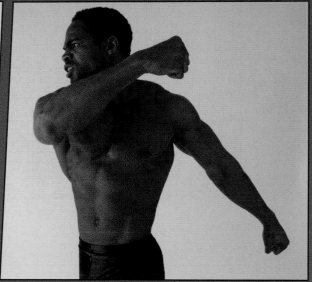

MITCHELL BREITWEISER demonstration ON PAGE 35

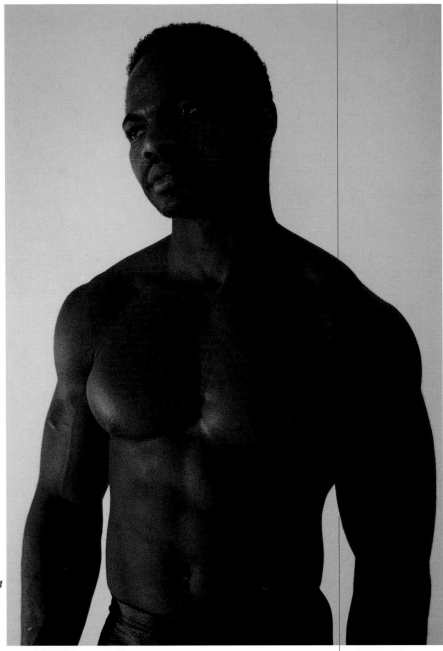

14

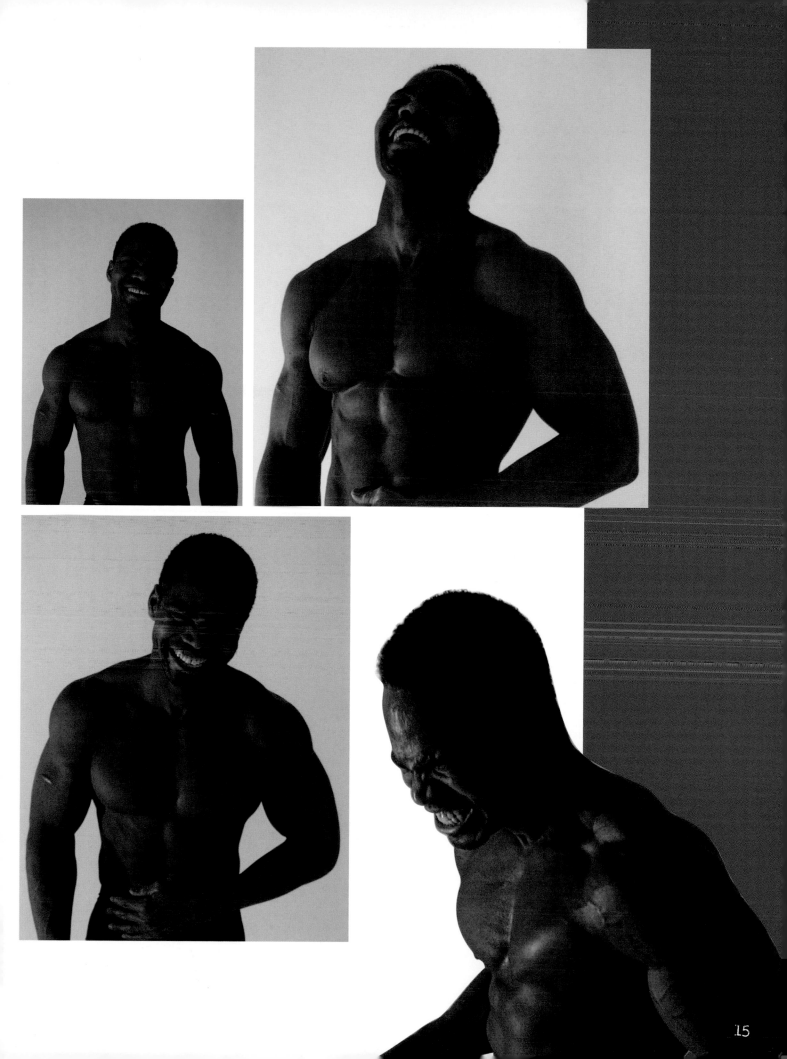

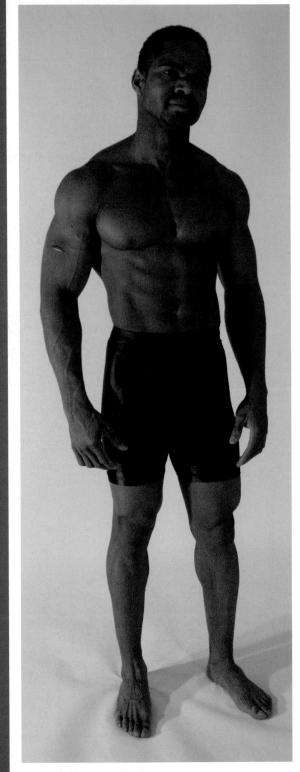

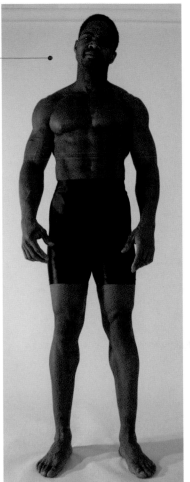

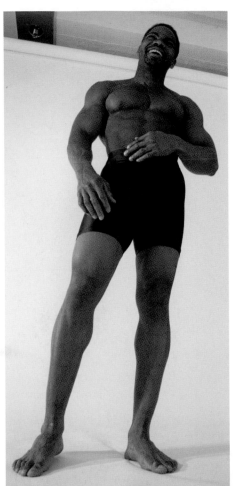

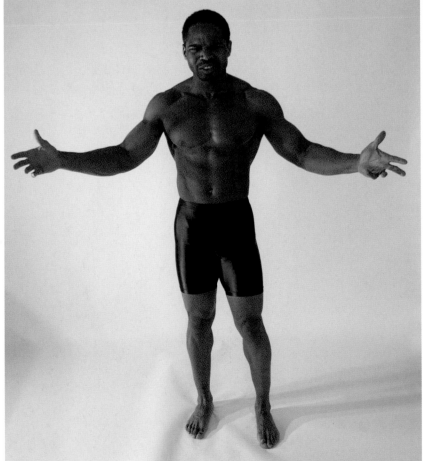

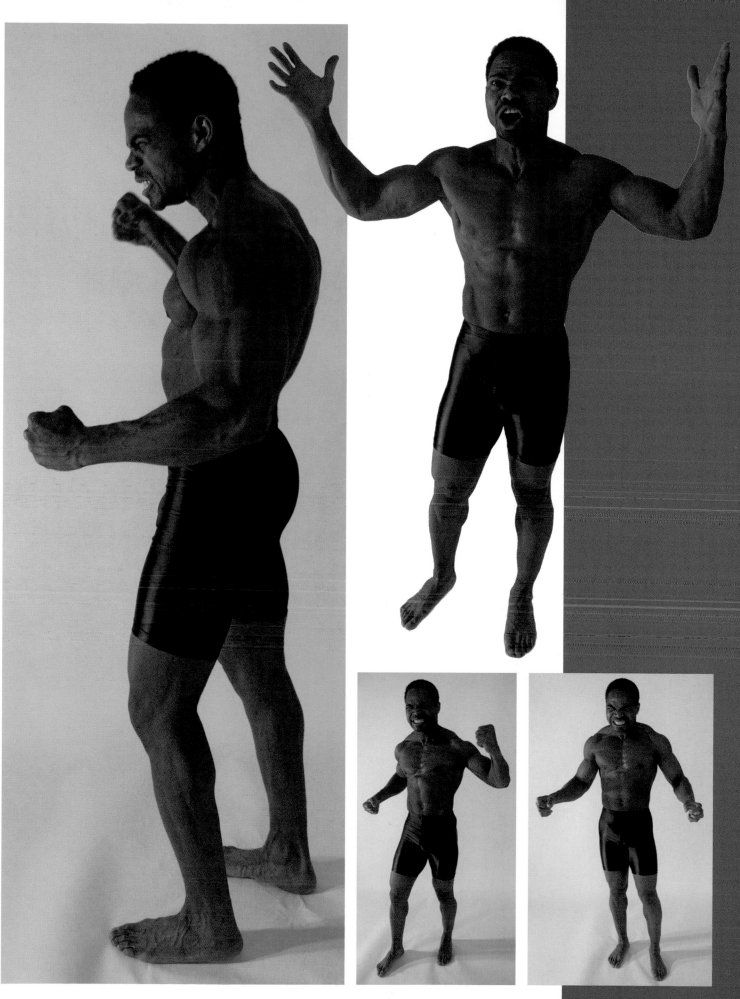

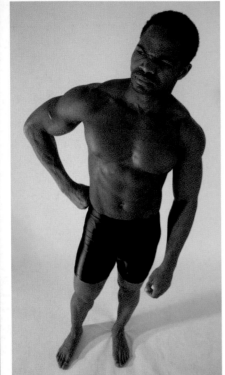

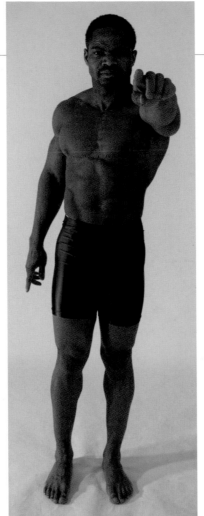

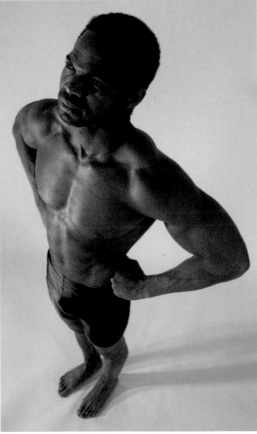

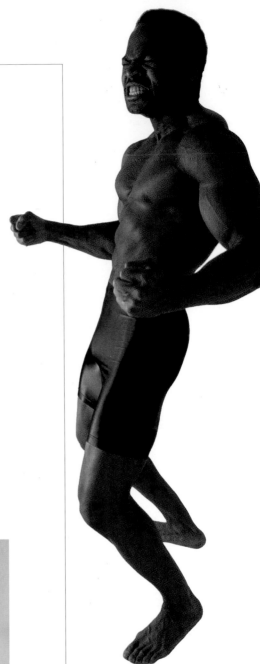

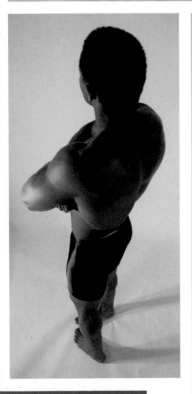

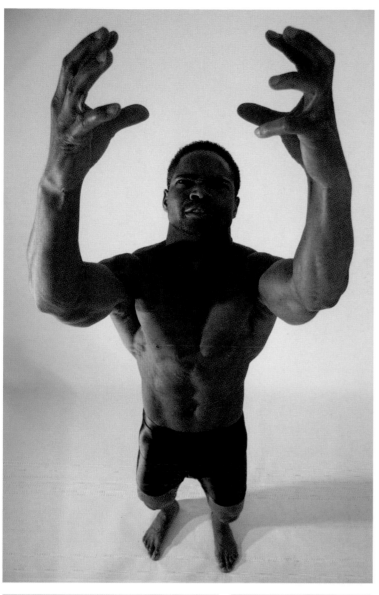

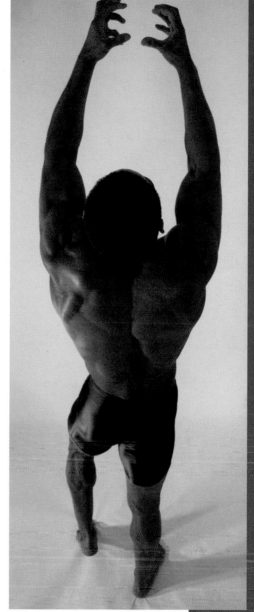

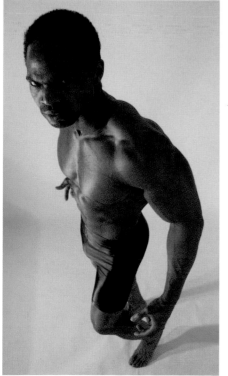

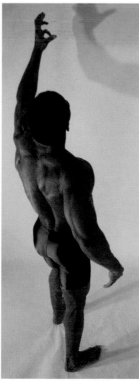

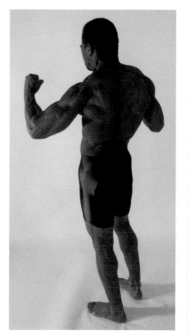

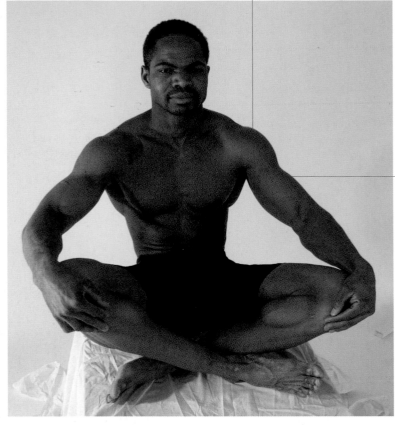

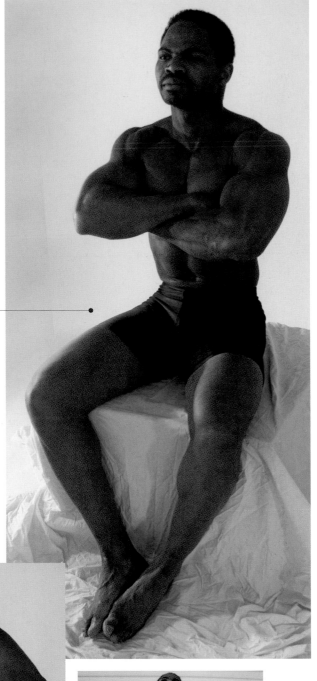

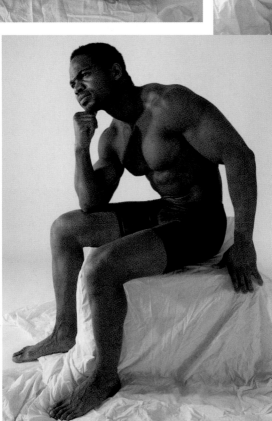

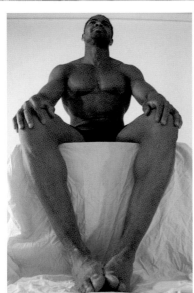

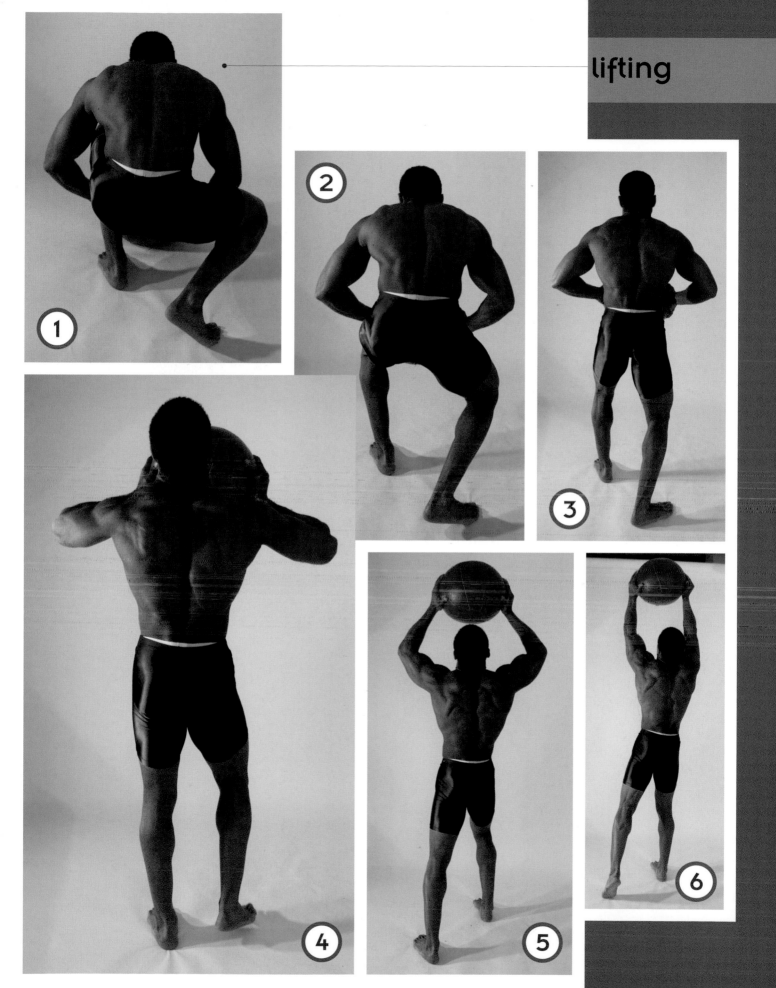

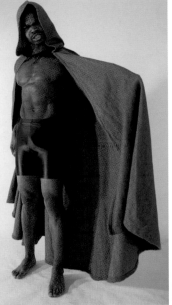

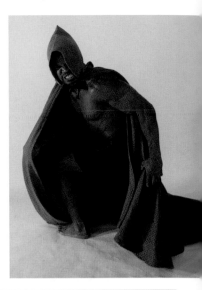

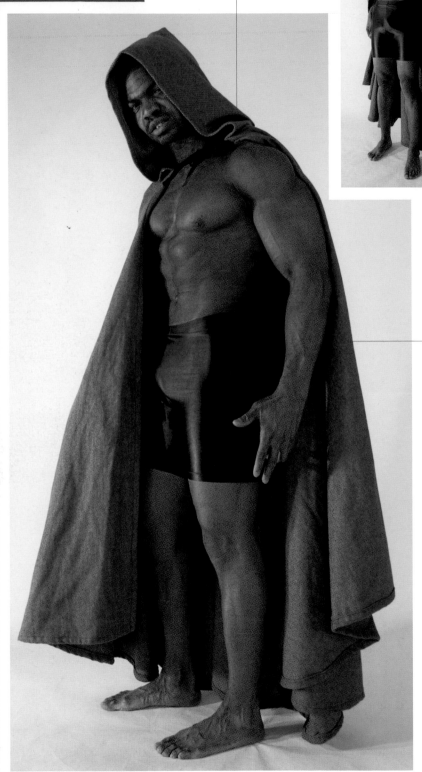

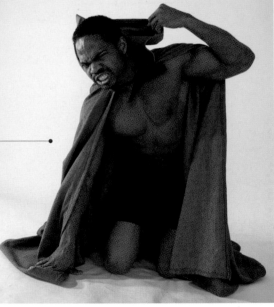

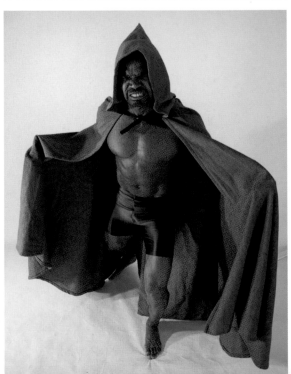

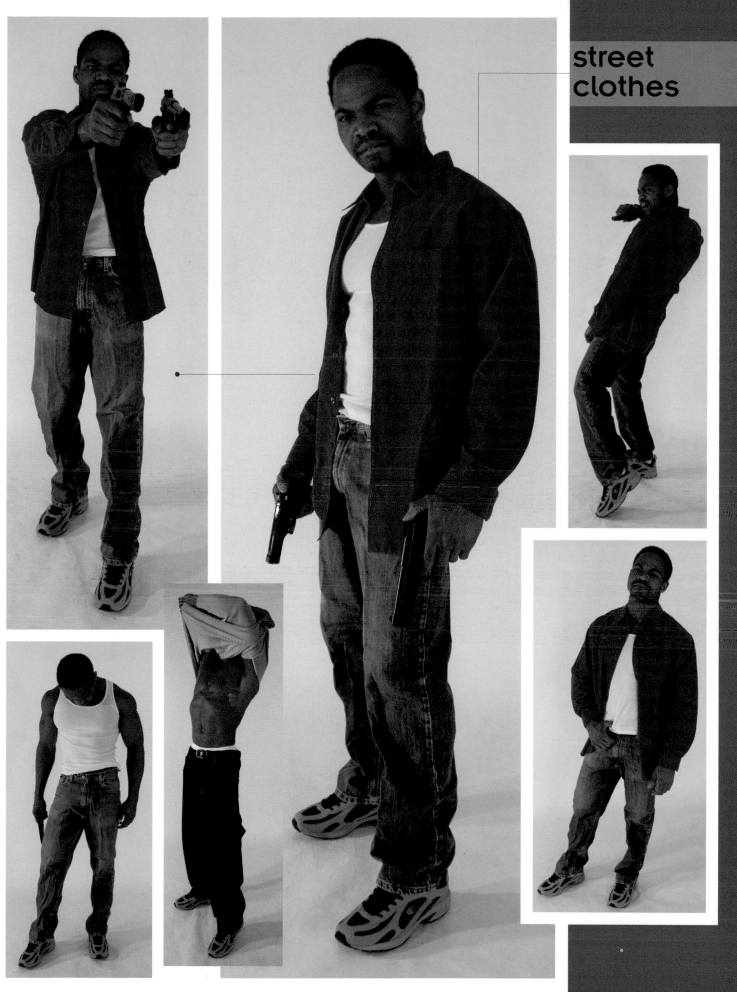

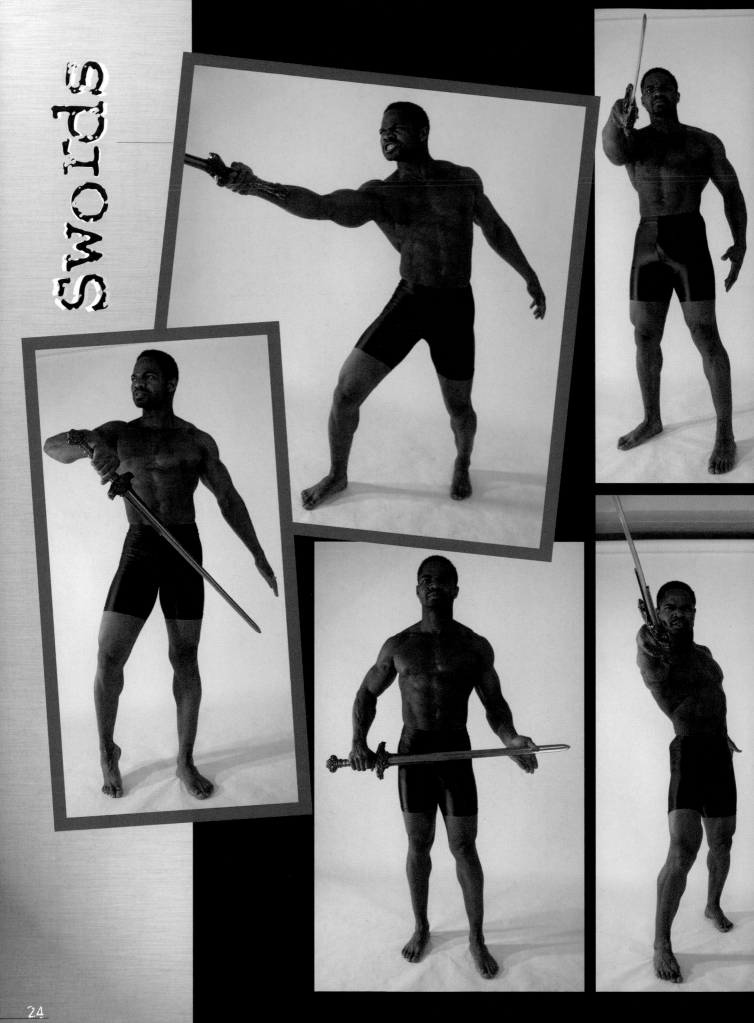

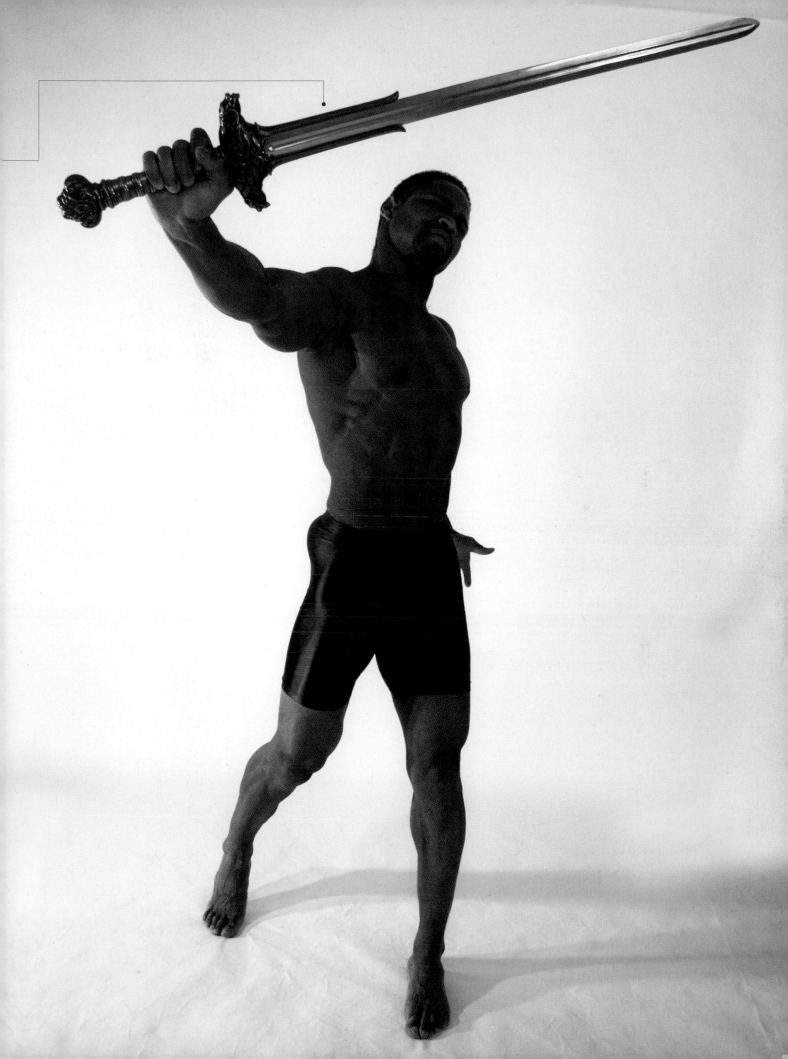

Guns

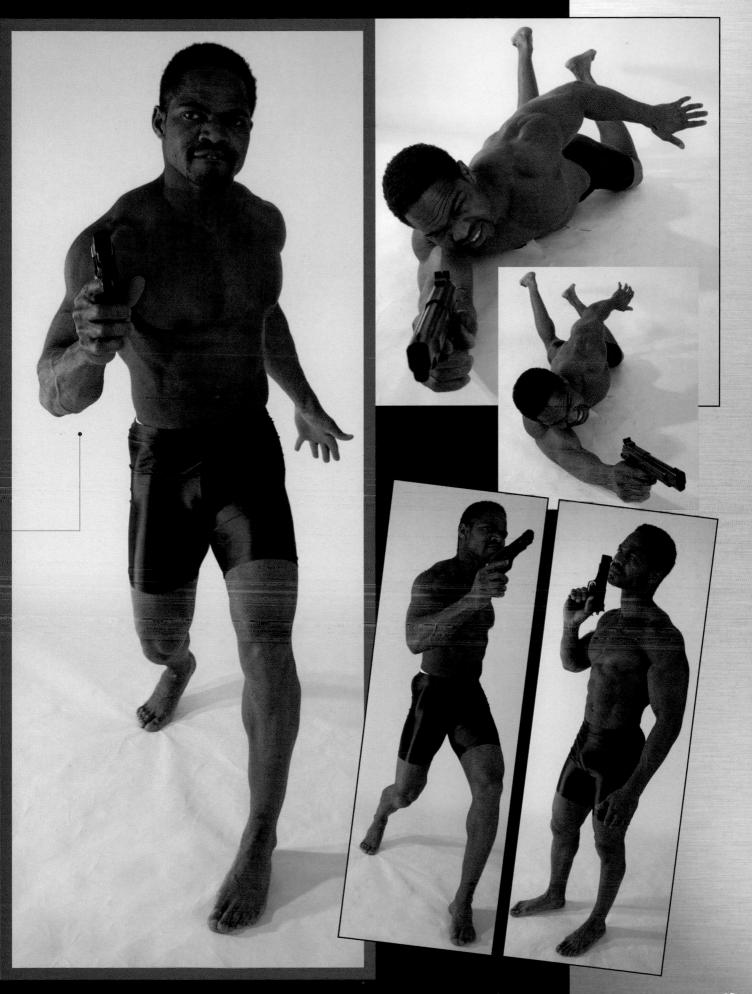

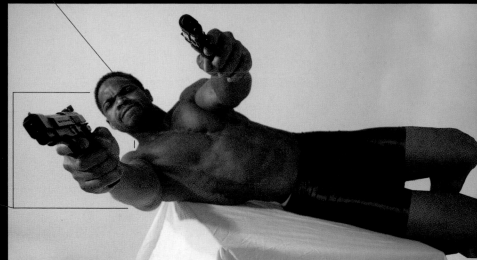

more
Guns

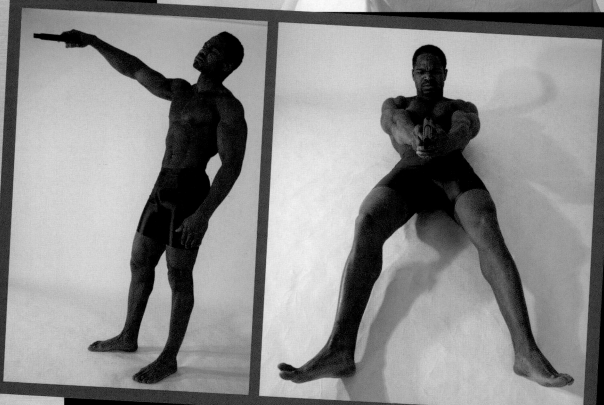

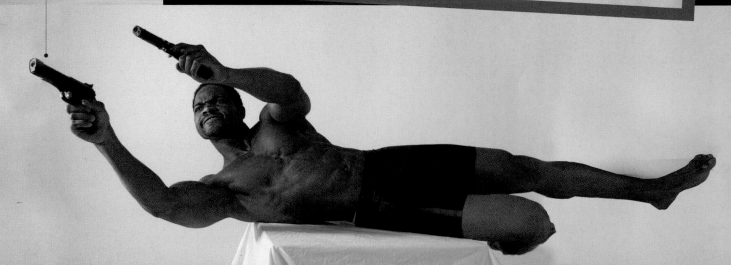

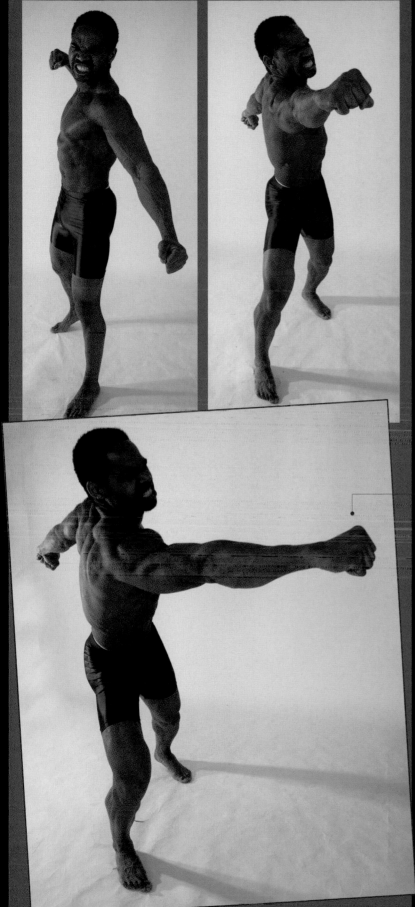

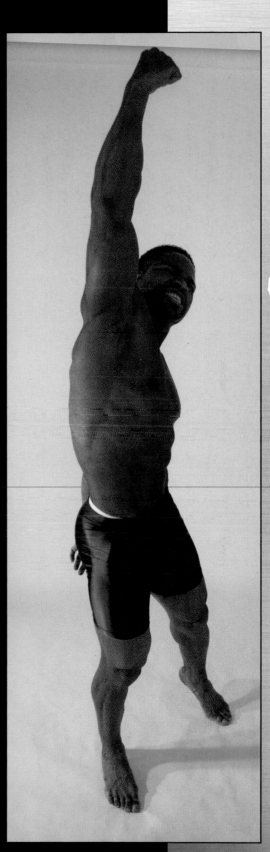

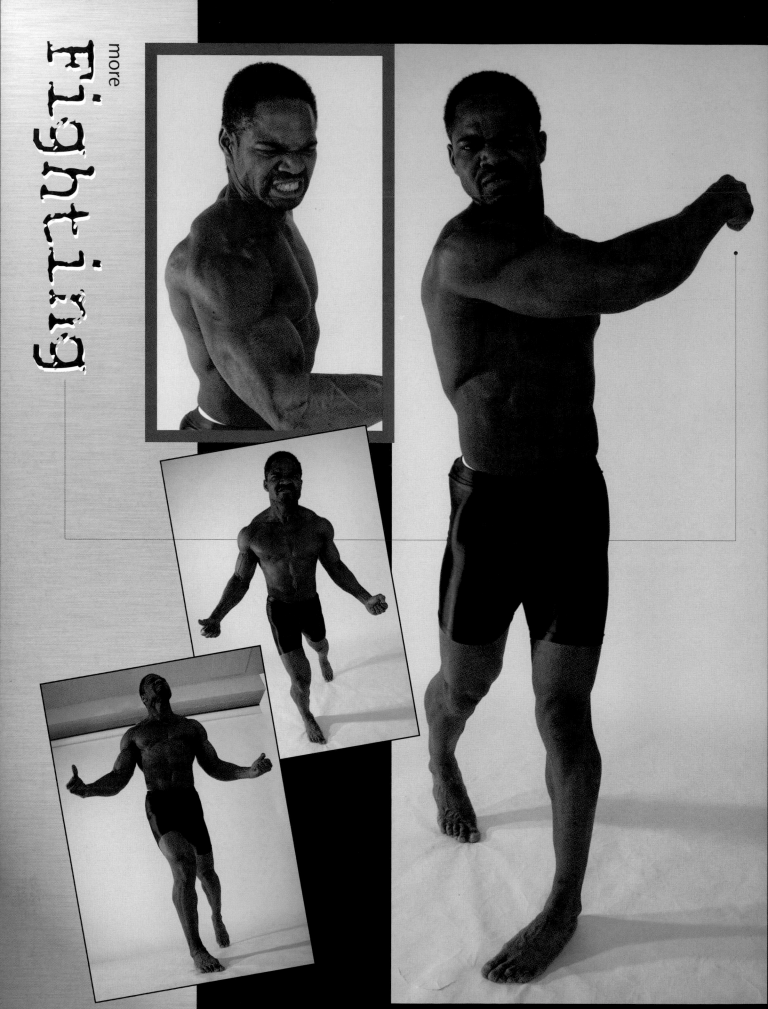

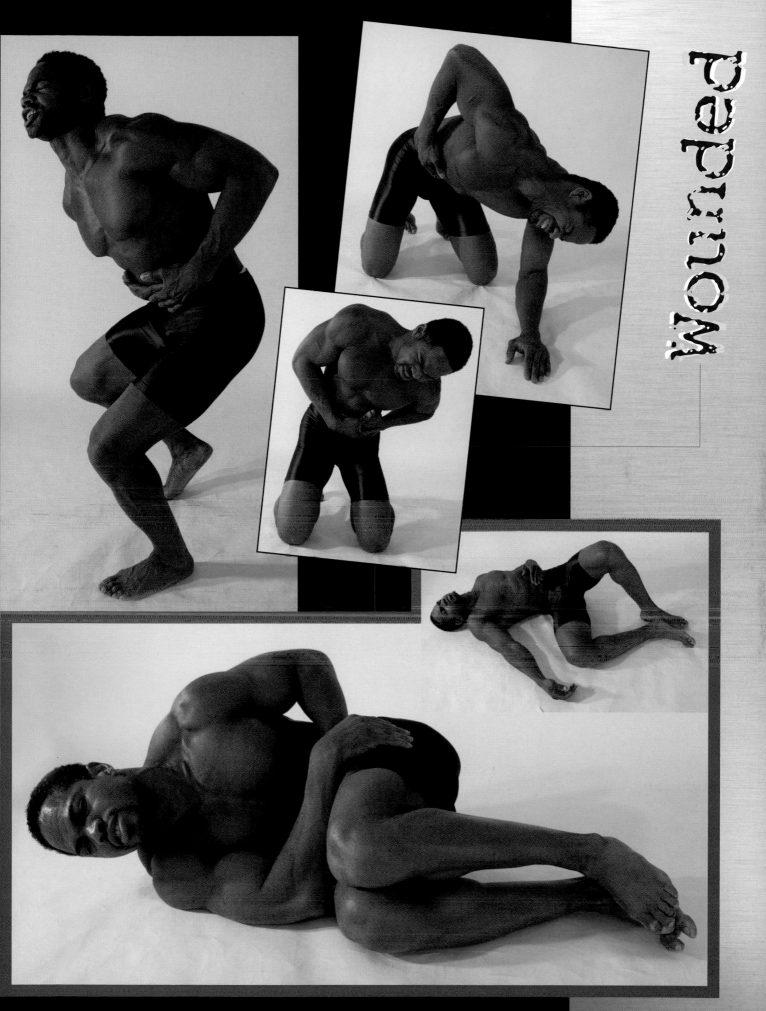

wounded

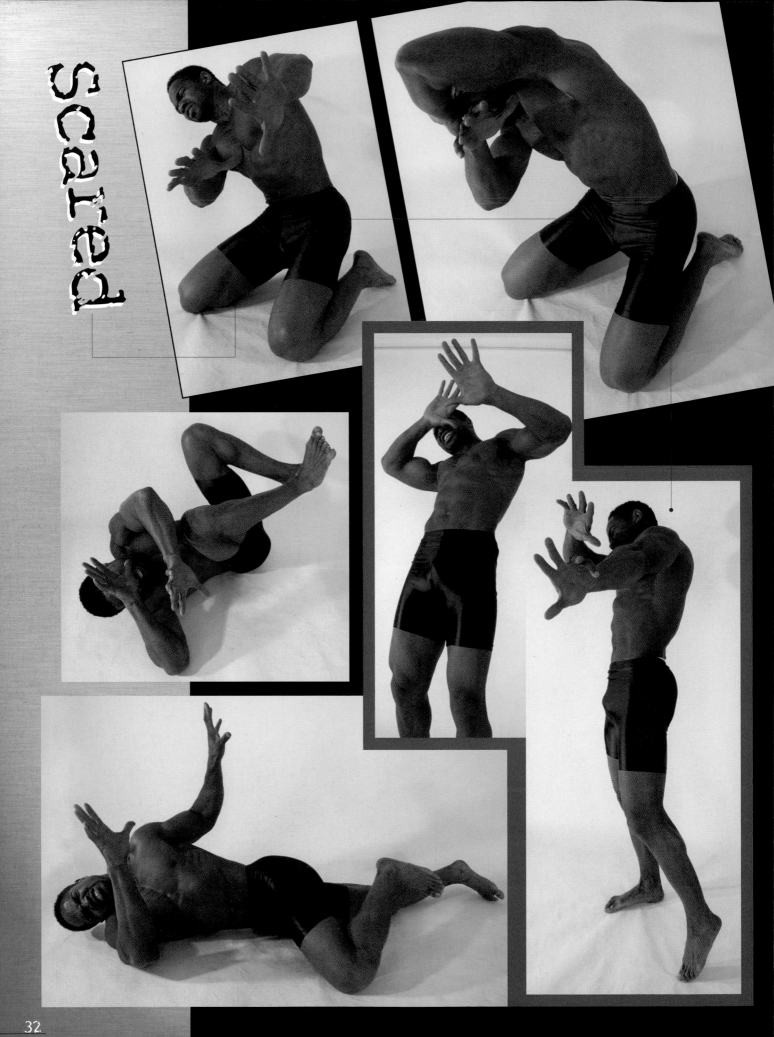

Scared

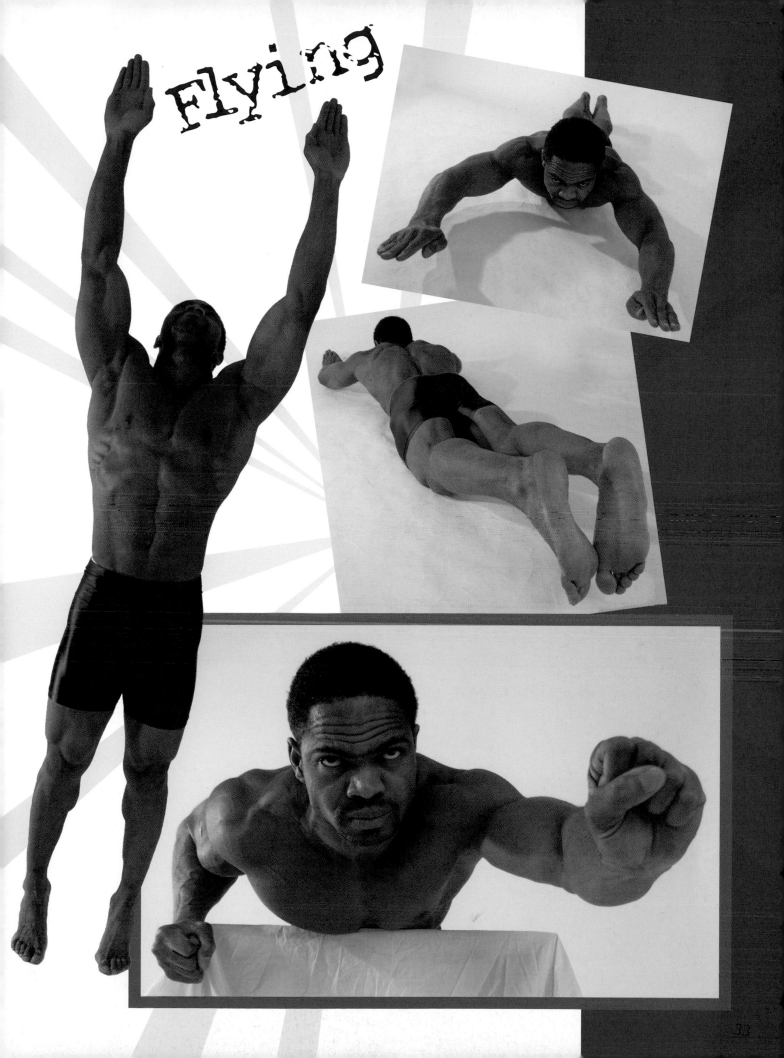

Flying

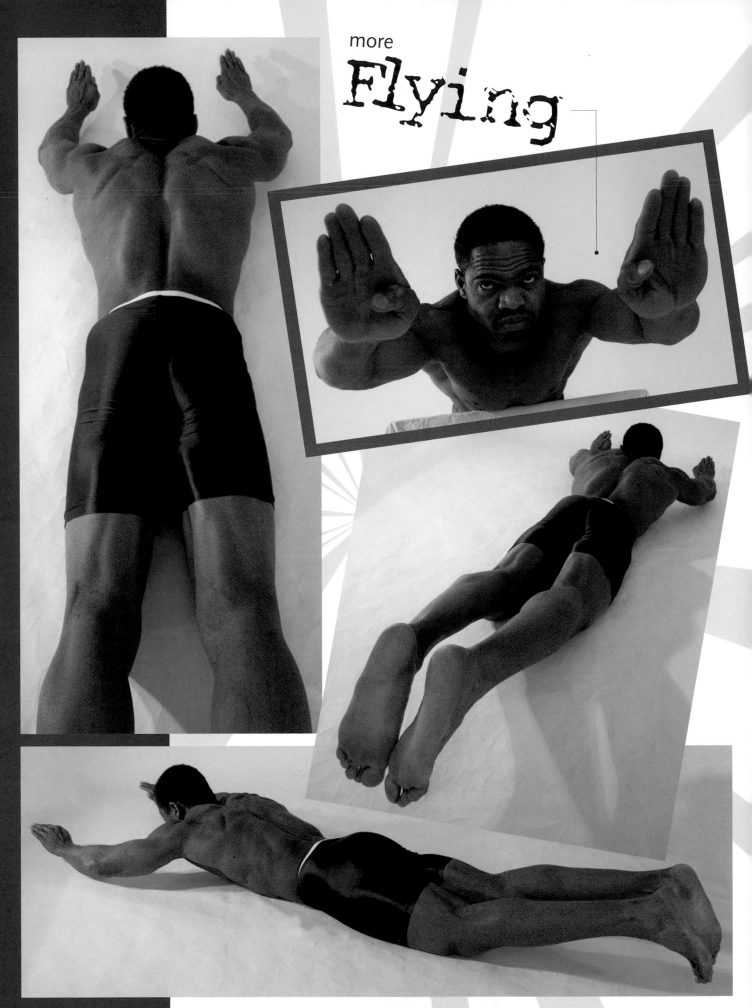

more
Flying

Create Mood

BY MITCHELL BREITWEISER

There are two ways to approach reference material. You can produce a rough sketch, then search out reference that fits what you have already drawn. Use this approach when you have a clear vision of where you want to take the artwork. Or, if you are experiencing a bit of artist's block, seek out reference first for inspiration. Look around for a photo that jumps out at you or captures the general mood you are hoping to achieve for the finished art.

I consider myself more skilled at inking than penciling. Unlike most comic book artists, I never fully flesh out my pencils. I make most of my decisions during inking. I believe this makes my artwork more expressive and spontaneous.

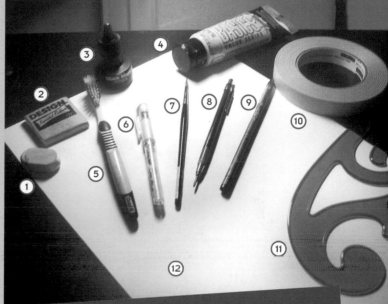

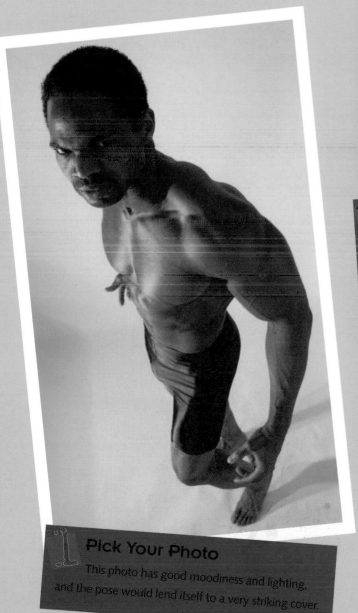

1 Pick Your Photo

This photo has good moodiness and lighting, and the pose would lend itself to a very striking cover.

2 Gather Your Materials

Here are the materials I used for this demo.

1. Plastic eraser—for completely removing pencil marks
2. Kneaded rubber eraser—for picking up excess graphite off the page or for cleaning up smudges
3. Higgins Black Magic ink
4. White acrylic paint—for spatter effects and fixing mistakes
5. Toothbrush—for spattering paint and ink for textural or atmospheric effects
6. White gel pen—for working white linework back into ink; a stylistic tool not essential for every artist
7. Winsor & Newton Series 7, no. 4 kolinsky sable brush
8. 7mm mechanical drafting pencil with HB lead
9. Woodless HB pencil—for broader strokes; also for softening inked edges
10. Drafting tape—for masking off areas during inking
11. French curves and rulers
12. Two-ply illustration board

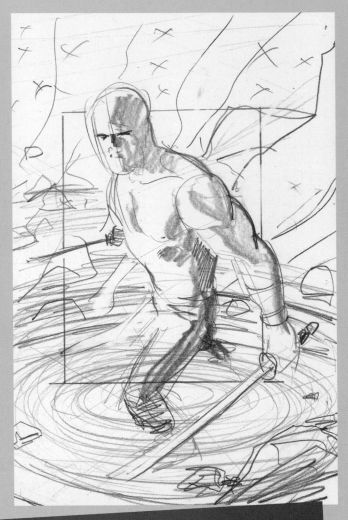

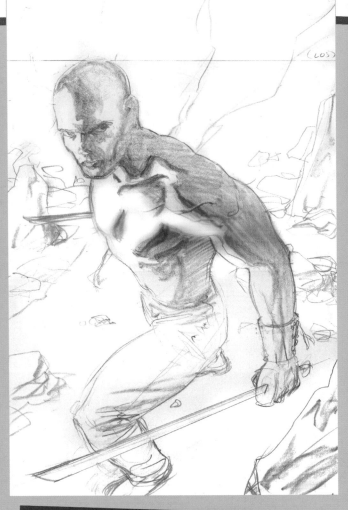

3 Do the Sketch

First do a preliminary sketch on any paper you have handy. Copy paper is fine. To keep the sketch loose, try using a woodless pencil, which creates a broader and somewhat clumsier stroke. Use the photo reference during this stage for lighting and general structure of the figure. Avoid fleshing anything out here, because you will make adjustments in later stages.

Design is paramount in this step, so here are some design tips to keep in mind:

1. Establish the light source now—it affects the artwork in every step.
2. Notice that the swords are not parallel. Keep them slightly off kilter in order to lead the viewer from the nearer sword into the figure and back to the other sword.
3. Use the steam or smoke lines in the background to "agitate" the figure. Making the steam flow in the direction opposite that of the figure creates visual tension.
4. Make sure to leave some breathing room. You don't want the art to feel cluttered or claustrophobic.

4 Do the Pencils

Now start your pencils on two-ply illustration board. Penciling is my least favorite step; I never fully flesh out my pencils. Try keeping yours loose, as I've done here.

Use the photo reference to help you get the muscular and vascular construction right, as well as the facial features. You can also deviate from the reference a bit. Notice how the arms on the art spread out a bit more than in the photo. If you make the head a bit smaller, the figure will look proportionally larger and more imposing. Also notice how the figure leans in quite a bit to make the pose look more aggressive.

tip
Draw your layouts at a standard comic book size to visualize how the art will look on the shelves and to the reader.

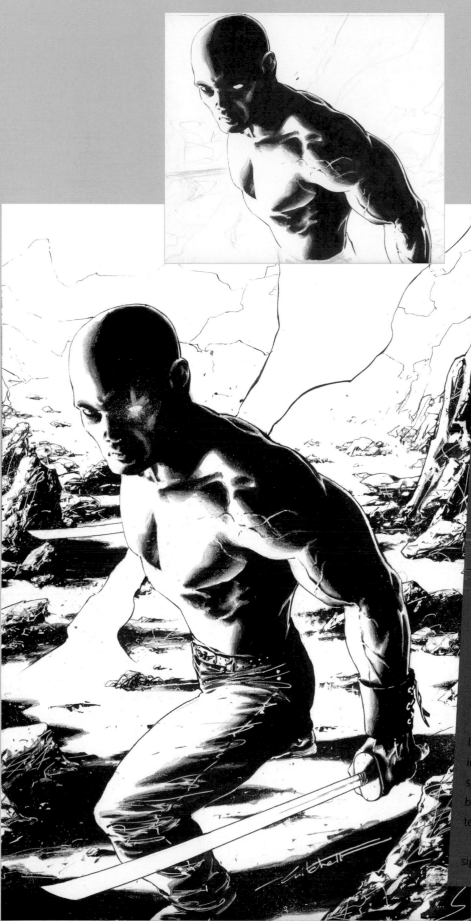

5 Ink It

Ah, the big payoff. So far, we have avoided detailed linework as much as possible. Now, with your inks, try to focus on dramatic lighting and textural and atmospheric effects. Many of today's artists are using less linework and hatching.

Try inking with a brush rather than pens for its expressive and spontaneous qualities. A brushstroke will give you more life than a pen. Although a difficult tool to master, a quality brush will allow you to achieve a wide variance in line weight as well as a variety of textures. Experiment with the dry-brush technique: Partially blot the ink off the brush, then drag it across the paper to create a rough textural effect.

Use an HB pencil around the edges of the ink to soften up some of the hard edges, especially on figures, where you want a softer, fleshier feel.

It's good to look back at the photo reference while inking. Keep it handy when working out the details of the face, as well as to double-check the muscular and vascular structure.

Finish by working some expressive lines from your white gel pen back into the rocks and clothing. Also try spattering some white acrylic onto the background for an extra little touch of texture.

Give it a once-over, deem it finished, sign it and call it a night.

Haydee

Hispanic Woman

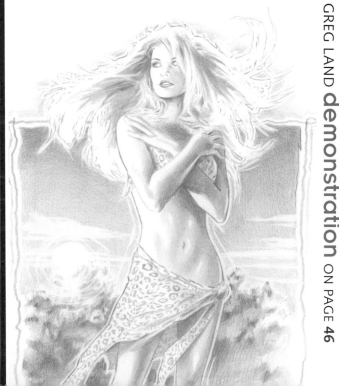

GREG LAND demonstration ON PAGE 46

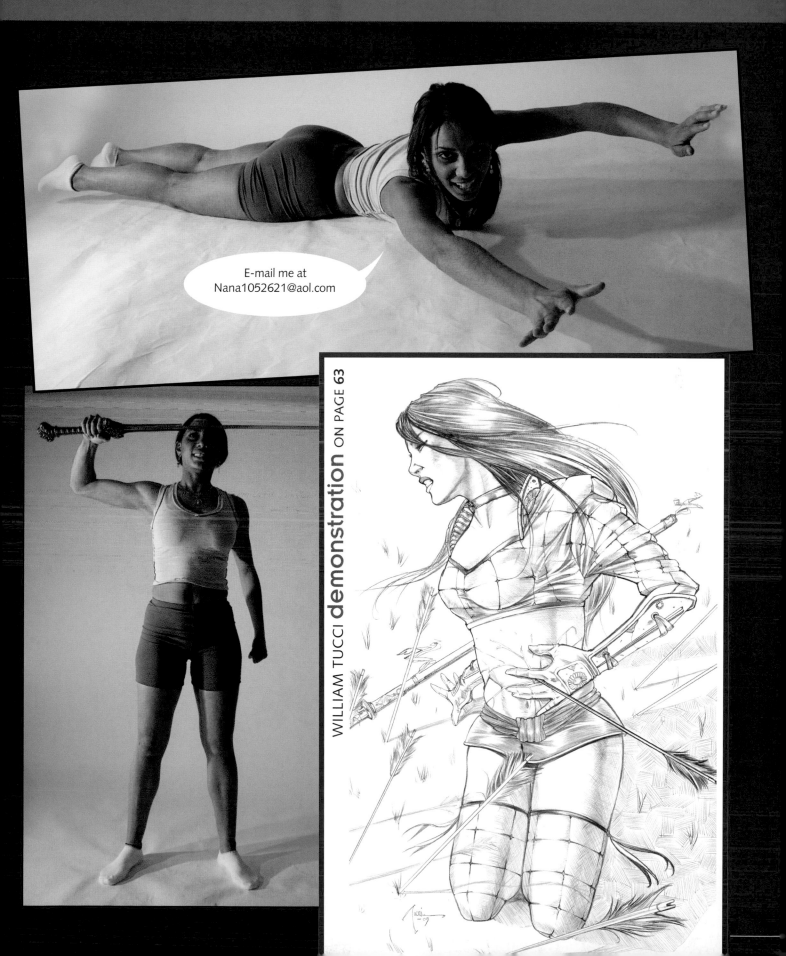

WILLIAM TUCCI **demonstration** ON PAGE **63**

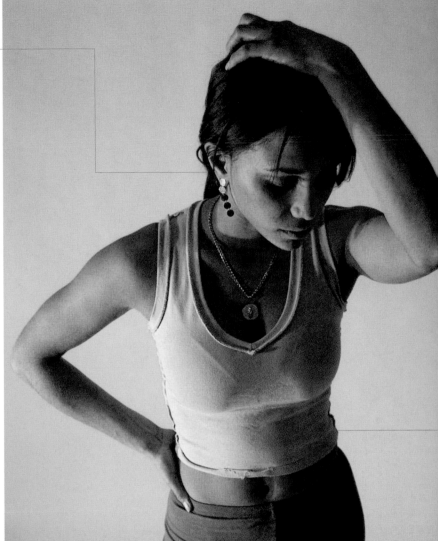

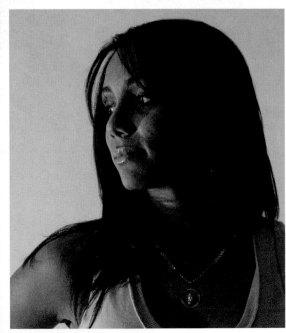

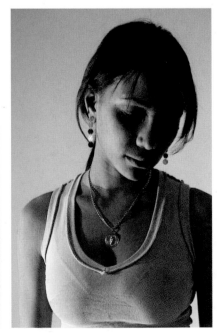

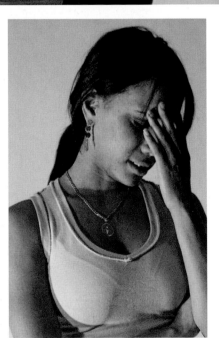

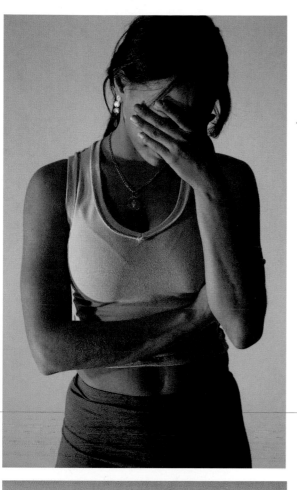
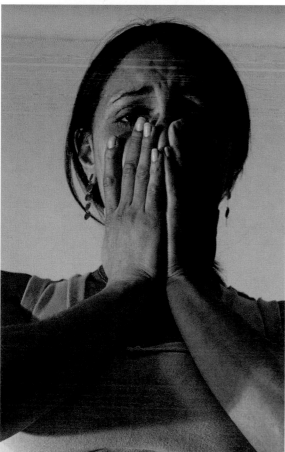
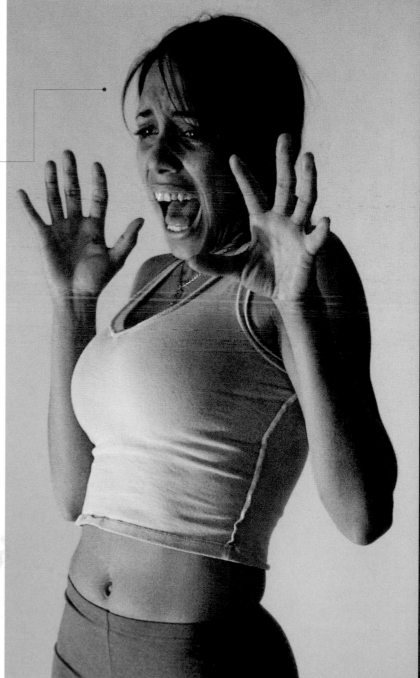

standing

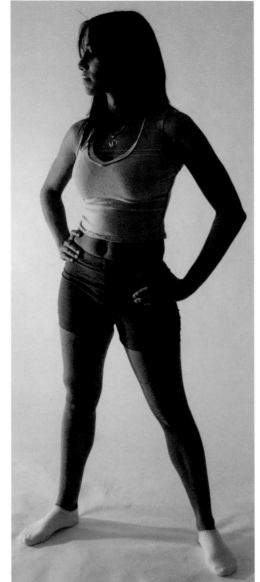

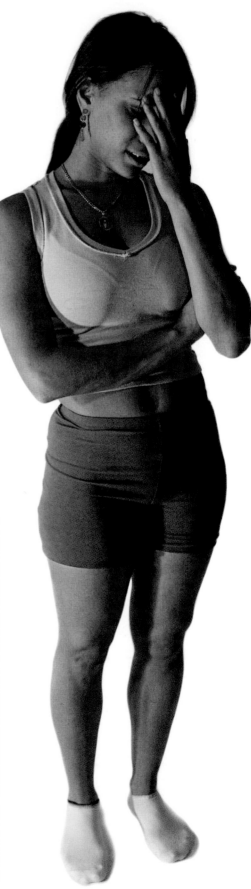

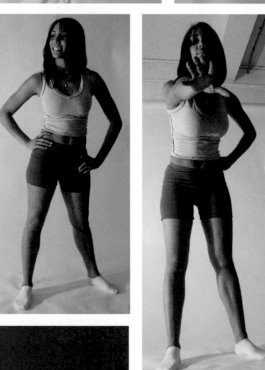

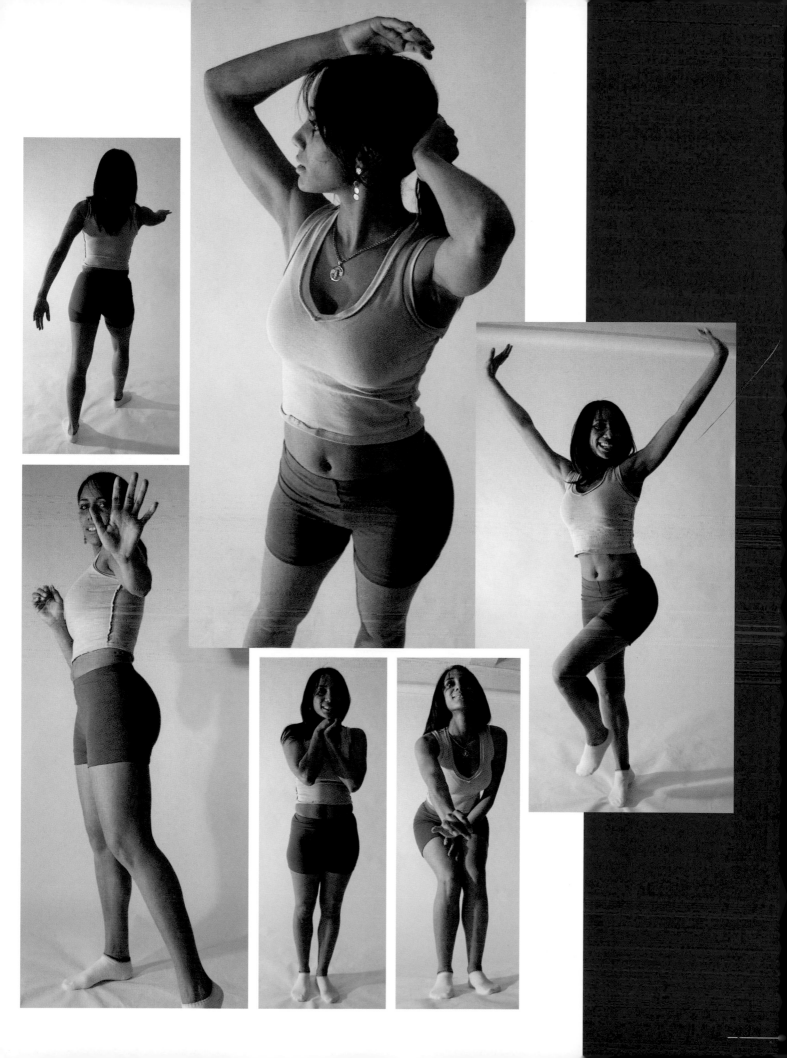

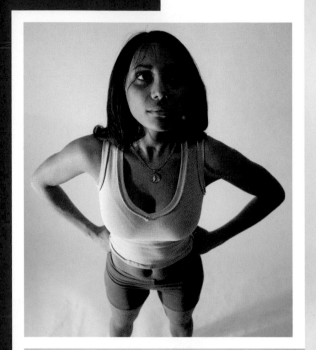

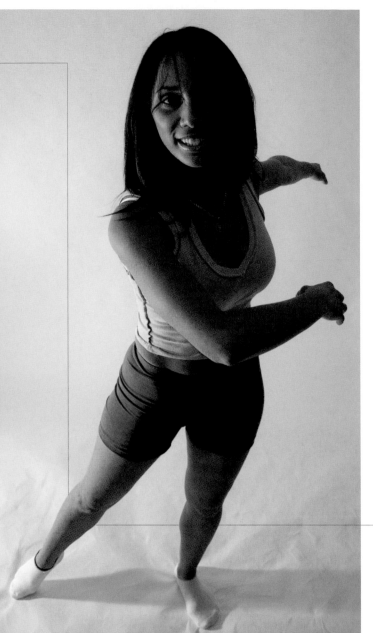

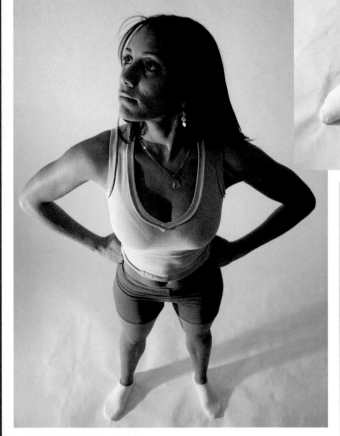

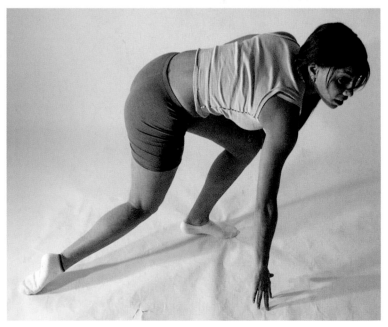

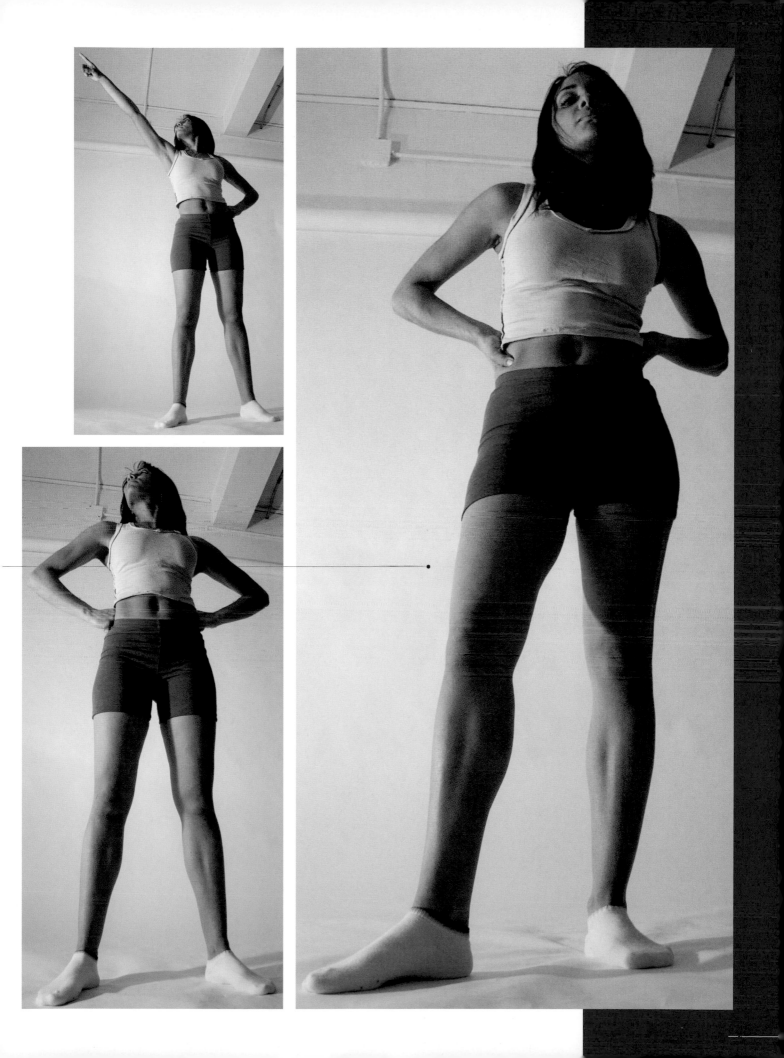

Demonstration

Draw a Beautiful Woman
BY GREG LAND

Comic book artists are often asked to draw beautiful women. Because the female form is inherently beautiful, this may seem like an easy task. Yet capturing the subtleties of the way women stand and move can be challenging. A good reference photo will help you to understand how to capture the nuances of the female form.

1 Find Your Photo

Every photograph captures a little piece of the model's personality. In this case, the photo reveals a playful yet sultry woman. Don't just look at the surface of the photograph; look beyond by imagining what your model is thinking. Read this woman's facial expression and her body language, and you will see someone who is relaxed and confident. Her slight smile and faraway gaze reveal a peaceful, private moment. Explore this book and the companion CD-ROM to find the photos that either capture a mood and expression that match your vision or simply inspire you to draw.

2 Photocopy and Find the Outline

Make a quick photocopy, enlarging the image to the size you want for your final art. Using a marker, "find" your character's outline. Remember, you do not have to follow every detail of the photograph. Your job is to interpret the photograph and make it into art. In this case, the final image will be a beautiful jungle girl, so you should find lines that make the model look as slender and athletic as possible. Sketch a few lines to indicate how you think jungle clothing will drape on this figure.

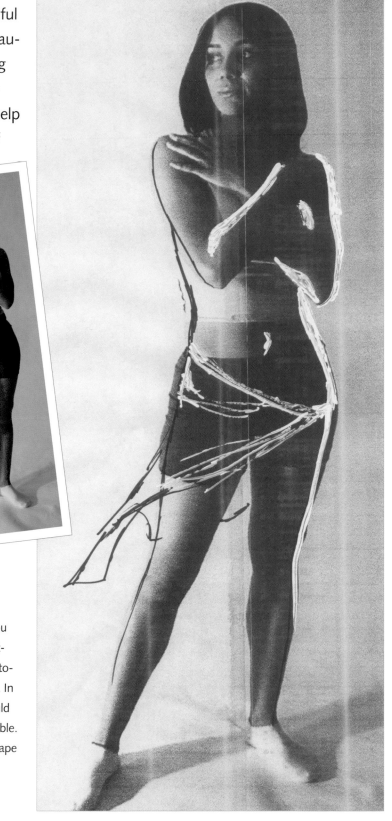

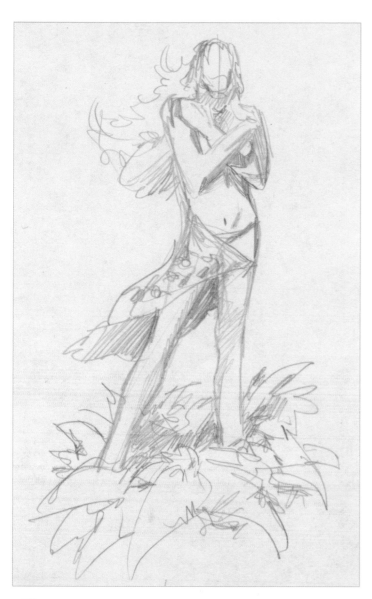

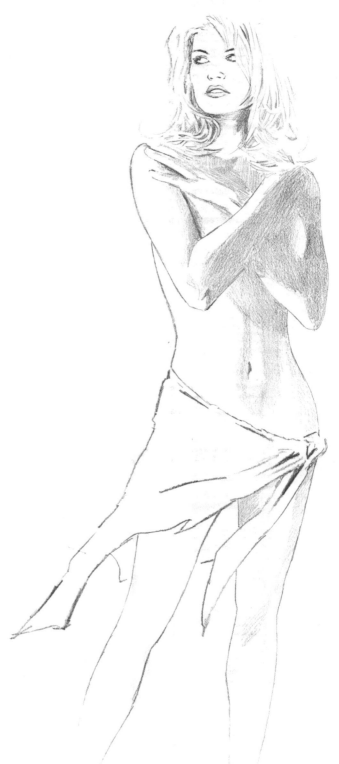

3 Rough a Thumbnail

Start with loose pencil lines that capture the gesture of the pose, using a soft lead pencil such as a 2H. (Later, you can go back with a variety of harder lead pencils to tighten and finish the piece.) If necessary, trace over the gesture lines that you created in step 2. This will help you maintain the proper scale and proportions. Erase lines that do not create the right form. Since this is a glamour sketch, go for the aesthetic of the "ideal" female form. Draw longer, thinner limbs. Rough out the hair, clothes and background just enough so that you know where your illustration is going.

4 Begin the Drawing With a Loose Sketch

Find the right lines by referring to the reference photo, which will show you the direction of the light, the placement of the hands, the angle of the face and other key details. Draw the kinds of features readers expect to see on this sort of character, including full lips, a petite nose, and eyes that have a nice darkness around them to draw the reader's gaze to the pupils.

 ## Tighten and Finalize Your Sketch

Add shading on the arms and loincloth based on the shading you see in the photo reference. Insert visual imagery in the background to convey that this woman is in the jungle. When you add the background art, keep things flowing in a standard Z pattern (see **TECHNIQUE** below) so you can control the way the reader absorbs your art. Keep the background simple so that the reader's focus is on the figure.

the Z pattern

Even on pinup art like this, you want to control the reader's eye, just as you would on a sequential page. Design the page so the images guide the reader's eye in a Z from top left to top right, then diagonally down to bottom left, then across to bottom right. The Z pattern is ingrained into us because of the way we read. If you did something that went against that, it would be like missing a gear when you drive a car: You can keep going, but you have to retrace yourself to get into the correct gear again.

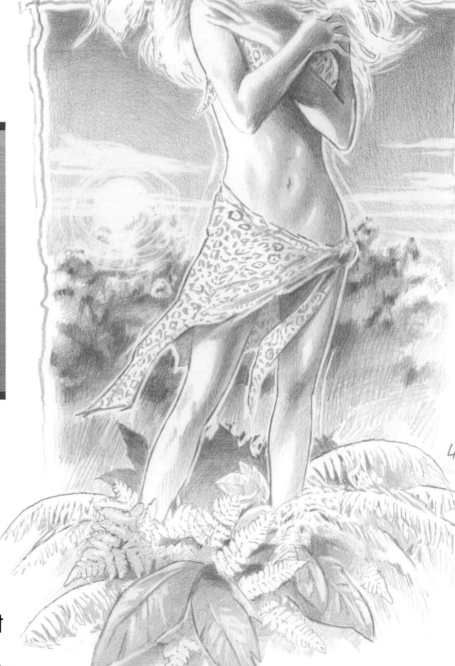

I know what a tree looks like, but when I draw one, I want there to be a realistic feel to it. I could wait for the right time to sit in the yard and draw that tree, but in reality, I have deadlines, so I use photo reference to get the realism I'm trying to achieve.

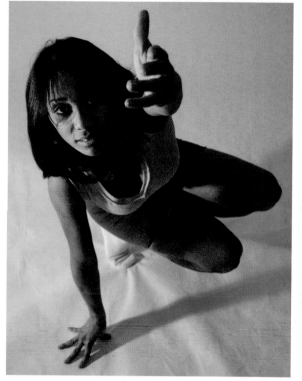

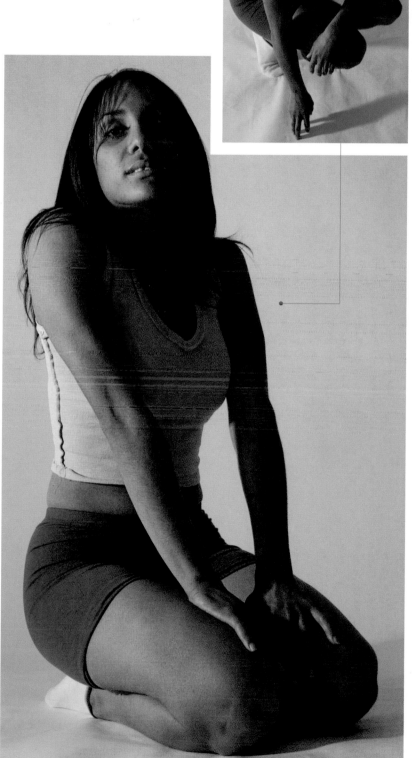

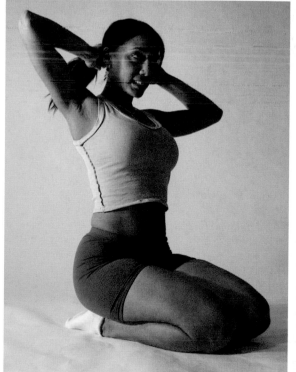

lifting

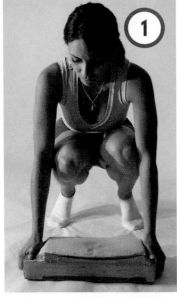

1

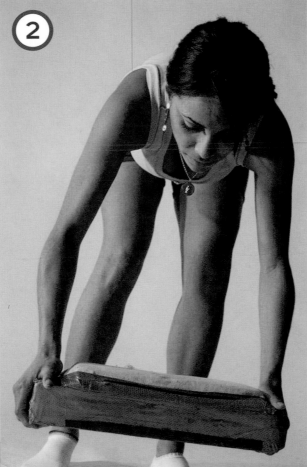

2

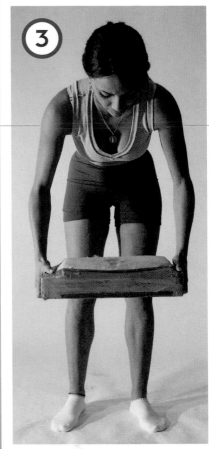

3

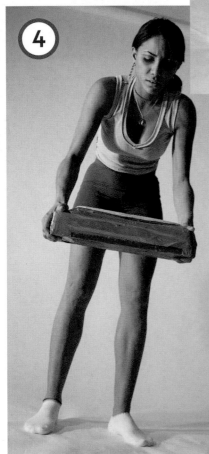

4

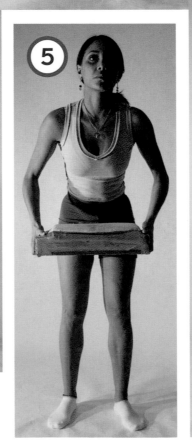

5

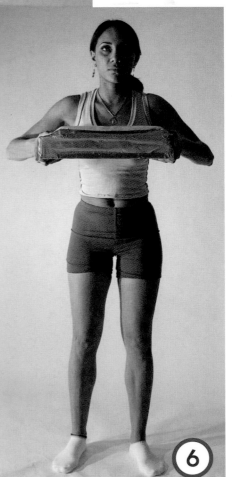

6

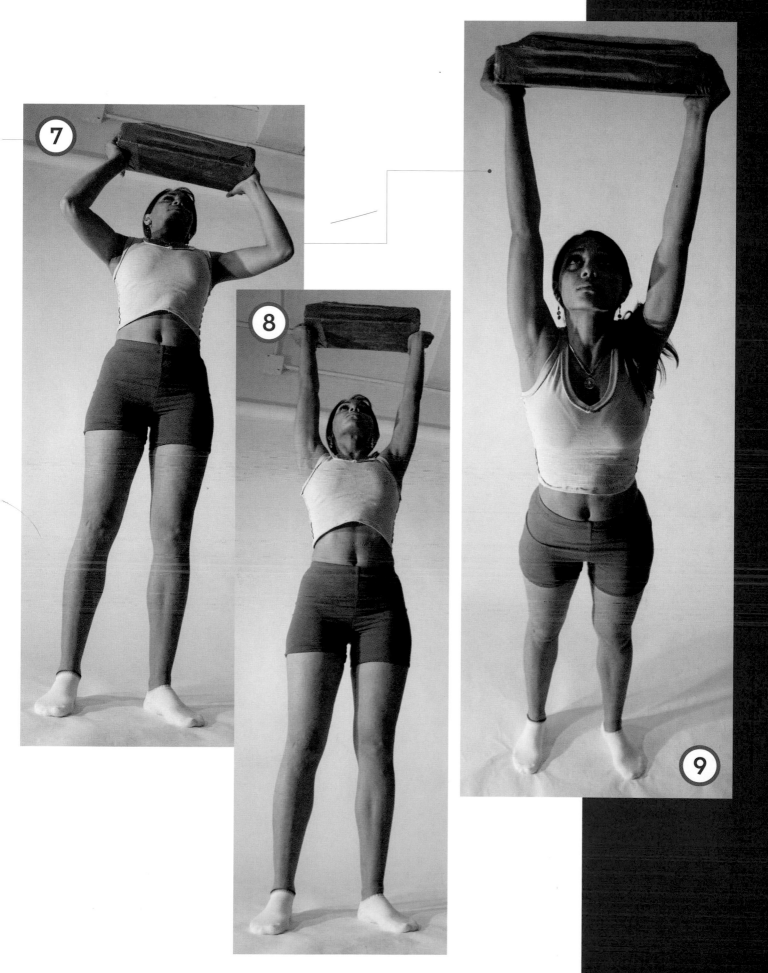

cape

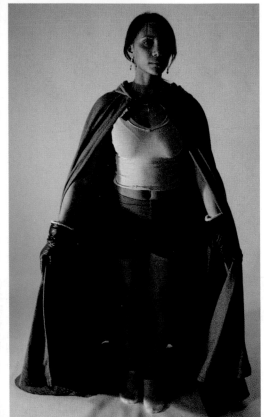

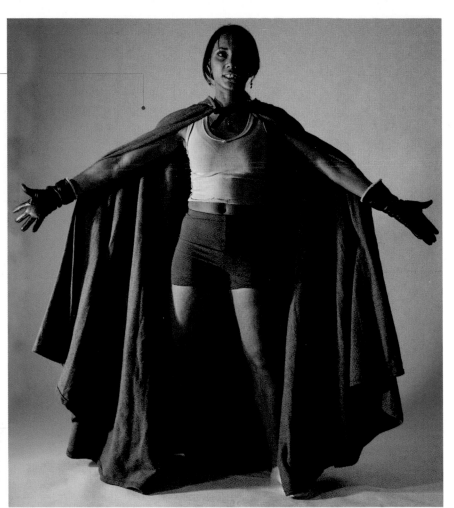

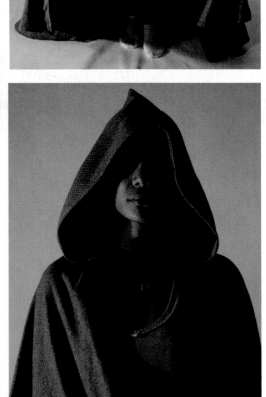

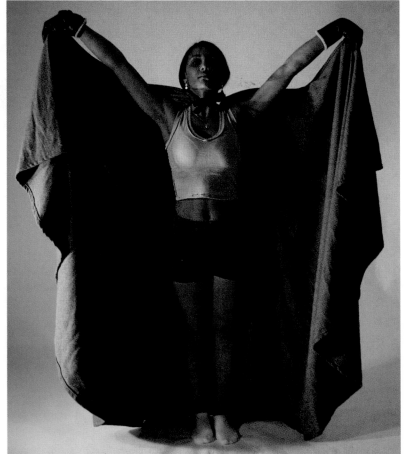

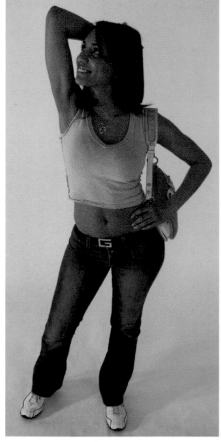

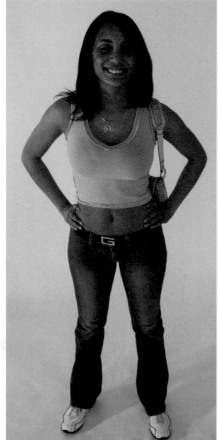

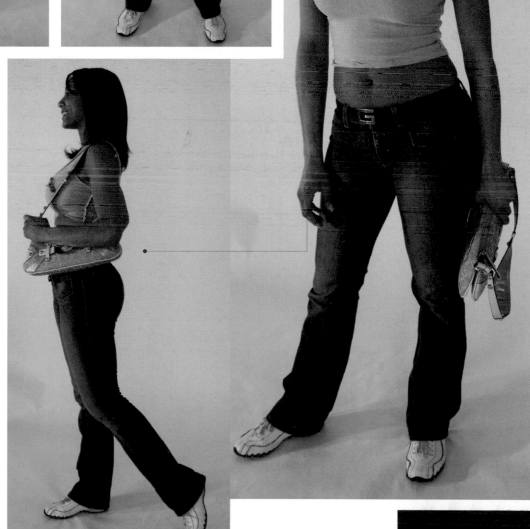

swords

54

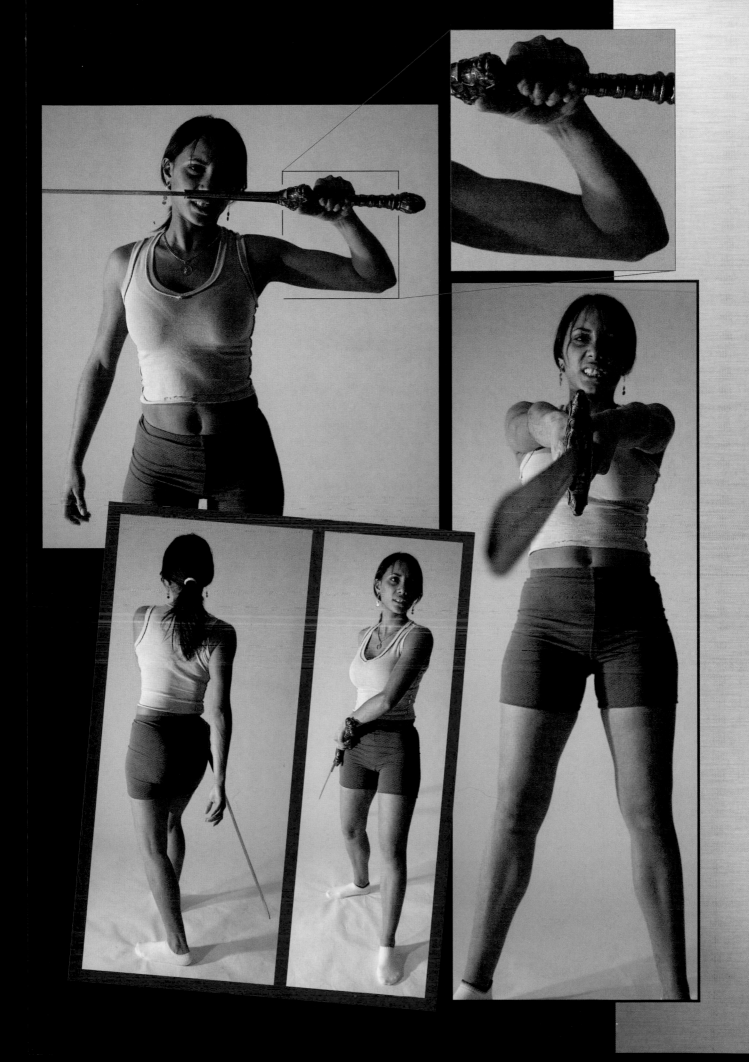

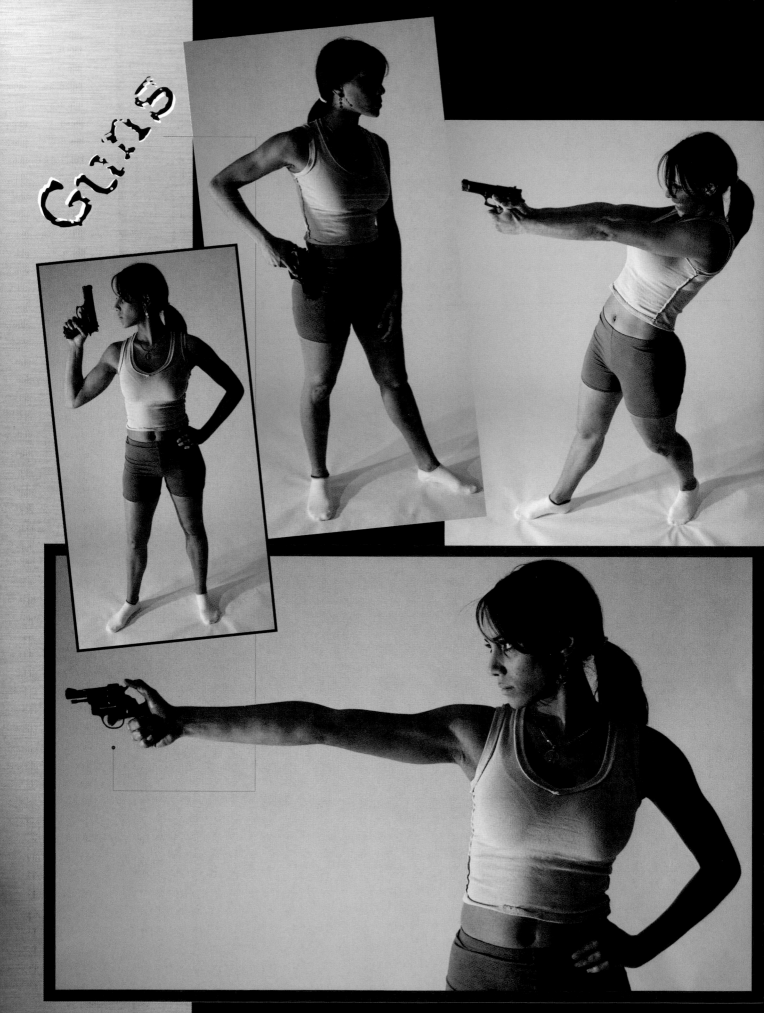

Guns

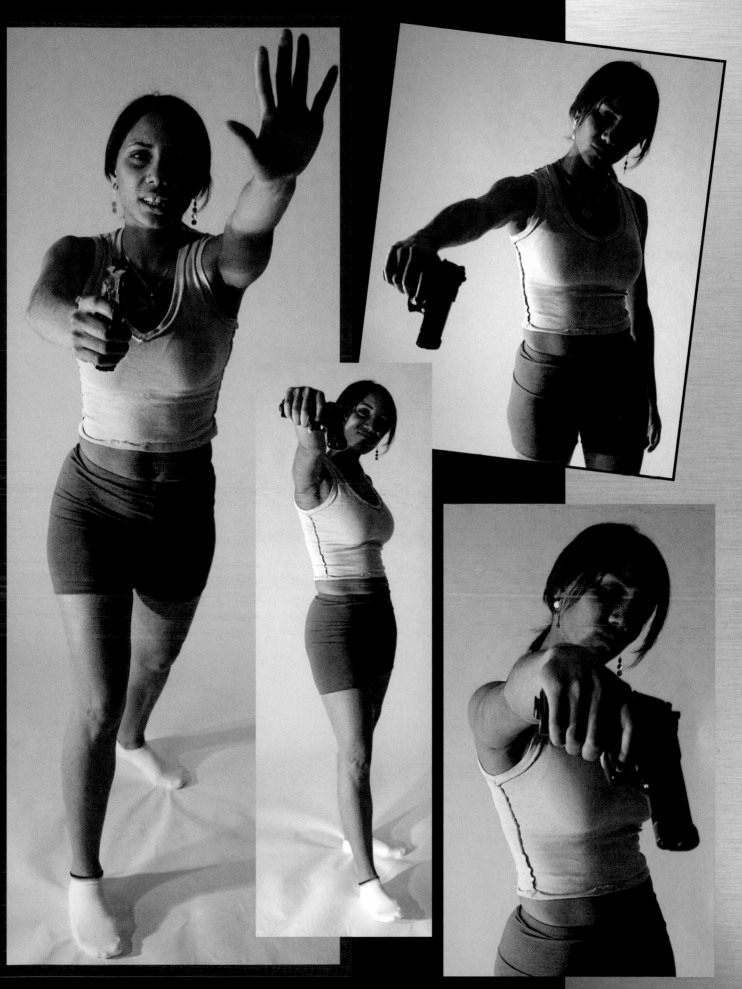

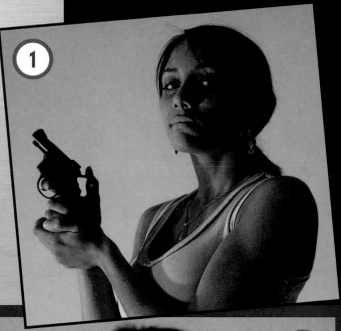

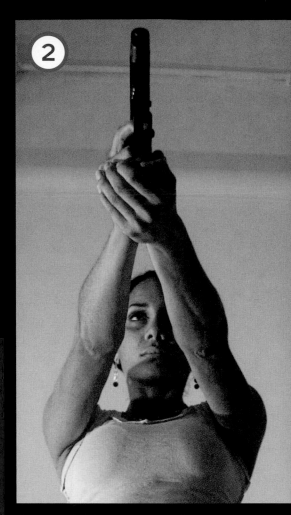

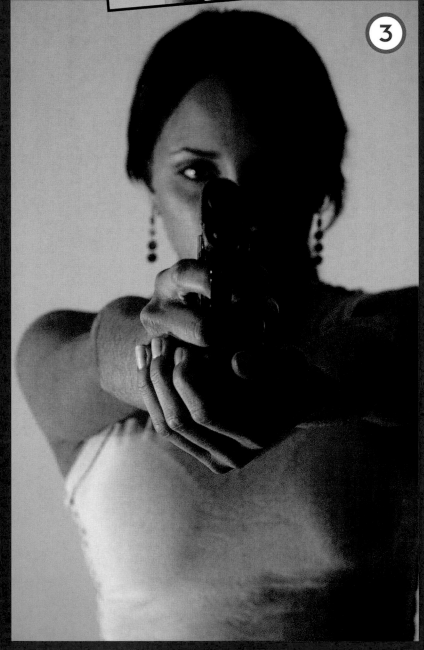

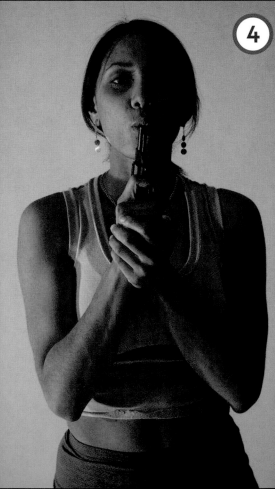

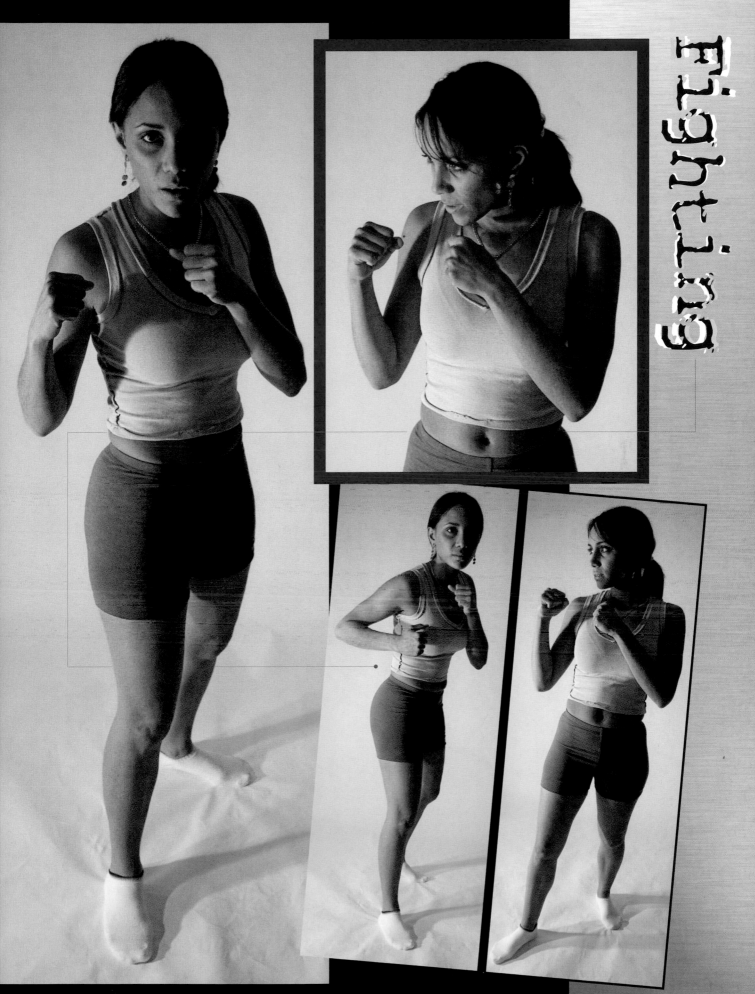

Fighting

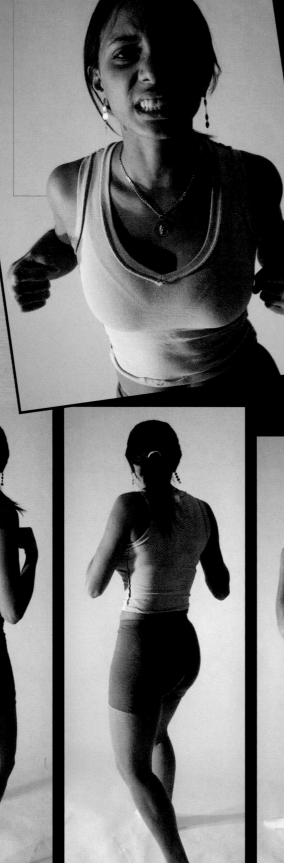

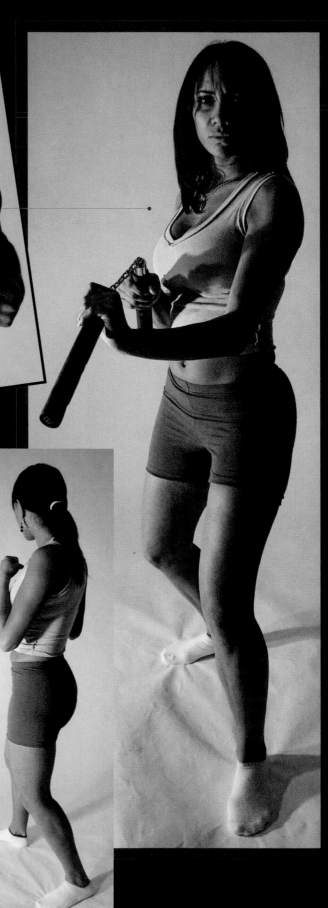

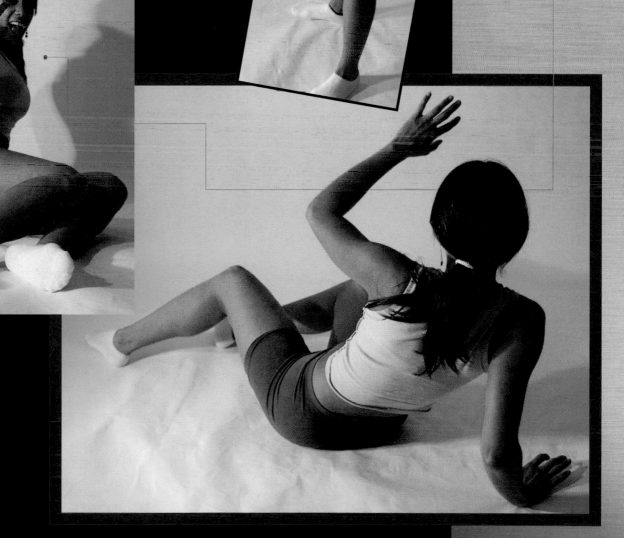

Scared

wounded

Work From Studies

BY WILLIAM TUCCI

I'm not the fastest artist; in fact, drawing is pretty laborious for me. So I like to do a few quick studies before I go to the finished art. You can work out mistakes and revisions in studies so that when it comes time to draw on the actual board, your artwork will be much cleaner.

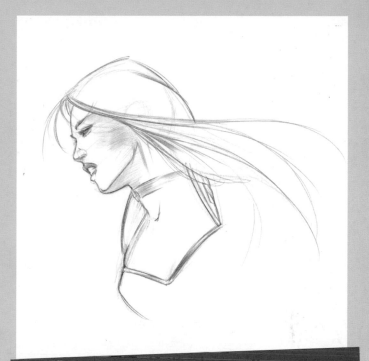

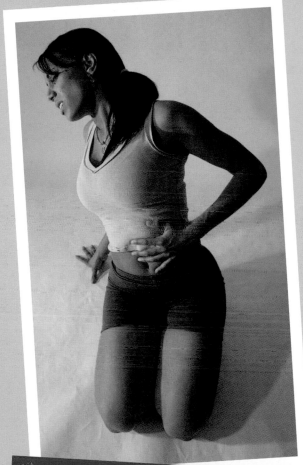

Do a Head Study

Hair is very important when you are drawing female characters. Shi, the subject of this demonstration, has beautiful, flowing hair. The model in the photo has her hair pulled back, so it will take some rough lines to get Shi's hair right.

Find the eyes, jaw and nose and indicate them with blue line. Then, with graphite, work up a fairly detailed facial study, even though you may change some of the details later.

Find Your Photo

We're going to draw my character Ana Ishikawa (a.k.a. Shi) being shot with an arrow. (The title for this illustration could be: "Please, God, Don't Let It Be My Liver.") I like this photo because it could be from the point of view of the arrows, which will be raining death from above. This photo has the energy and drama I need.

Study the image to get a grasp of the body position before committing anything to paper. Notice the hand in the back; without it, it would be impossible to tell that this is a high-angle shot. That important detail will give the illustration depth.

Study, study, study. Draw, draw, draw. Study anatomy. Draw from life. Draw from photo reference. You'll draw many things better when you're referencing a photograph than when you try to do it from your head. Really know your stuff.

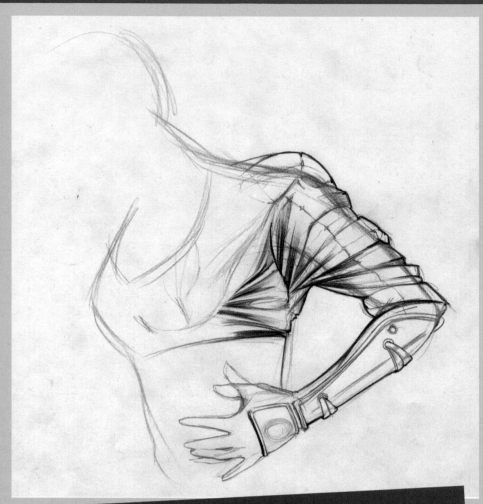

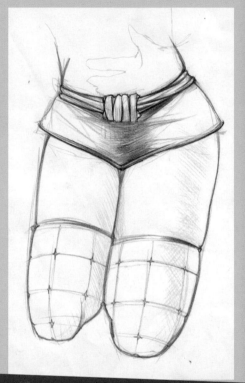

Do a Shoulder Study

In your shoulder study, figure out how the clothing material will fold given the figure's position. Fabric will pull against the contours of the body.

Because the arrow is in Shi's abdomen, the reader's eye will naturally travel to this focal point. It's critical to think about the costume details here, such as how the gauntlet and sleeve are being affected by the position of the arm.

Do a Skirt Study

Because of the way the model is leaning and the position of her legs, the natural flow of anatomy is distorted. Moreover, the photo is from a slight side angle, so the legs will not be perfectly symmetrical.

The model is wearing shorts rather than a skirt, so to dress her like Shi, try to imagine how the skirt would respond to this kneeling position. Notice that the skirt does not drape straight down, but rather responds to the curves of her legs.

Draw as realistically as possible without tracing the photo. Where's the excitement in tracing? I use photo reference to start off, but when I draw, I interpret and modify to give the final art more of a "living" look.

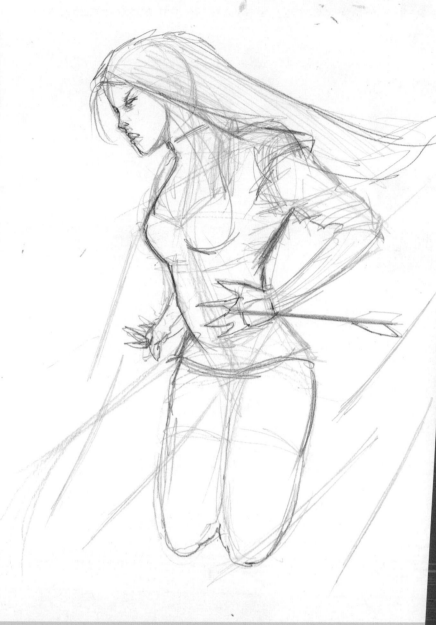

TECHNIQUE

gesture line

A gesture line is a guideline that shows the position and arc of the spine. This line allows you to push or pull the figure a little and still maintain the anatomy. The more you draw from reference photos and real life, the easier it becomes to find the gesture line.

5 Do a Rough of the Entire Figure

Start the rough using a blue pencil on a fresh piece of regular copy paper. Draw some lines to indicate the direction of the eyes, jaw and nose, and a gesture line (see TECHNIQUE below). This line follows from the base of the neck through the spine. In a standing figure, it's more evident because the gesture line travels down the spine, through the hip, down the legs, and to the feet where the weight is planted.

Here you can see how the neck and spine are positioned. The neck is turned a little, and you can see it in the line. This gesture line gives you a strong grasp of the image before you even commit graphite to paper.

Start sketching over the blueline with a soft graphite pencil. As you find the correct lines, tighten with a harder pencil.

Indicate the rain of arrows around Shi with rough lines. You can always decide to change their location later. Put in enough arrows to show that she's under attack from many enemies.

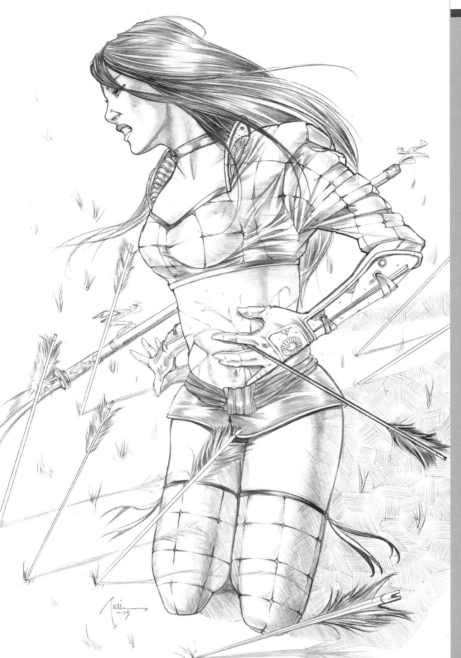

Since I don't use an inker, I have to make sure that my pencils are really tight.

make your art your own

Using photo reference will help you achieve proper anatomy and perspective, but if you are a slave to the photo, your art will come out stiff. So don't just copy; interpret and modify. Use photo reference as a tool, almost like the first link in a long chain that leads to the final art.

Compare the photo on page 63 to the final art here, and notice how I've made modifications to suit my needs. Shi's back is arched a little more than the model's. I've added long, flowing hair. These small changes in the details give the final art energy and motion.

Draw the Finished Art

After you complete your studies, put them on a light box and transfer them to bristol board. If you've been drawing in a notebook or on scraps of paper, you may need to modify the size of your sketches to fit the panel. If so, simply use a photocopier to scale your art up or down to fit your needs. Place the correctly sized art on a light table and transfer it to the 11" × 17" (28cm × 43cm) bristol board.

Draw in the elements that are not part of the photograph. Shi's weapon is a Japanese naginata. Putting it behind her hand shows that she's dropped it and that she's in real danger. It also creates depth and perspective by showing the viewer exactly where the ground is.

Next, draw the arrows. This is the fun part. The arrows on the ground cast shadows, giving the drawing extra depth and dimension. The light source for the photo is to the left, so to be consistent, make sure all your cast shadows fall to the right.

Finish the drawing by refining the details, such as the blood streaming out of Shi's wound.

Flying

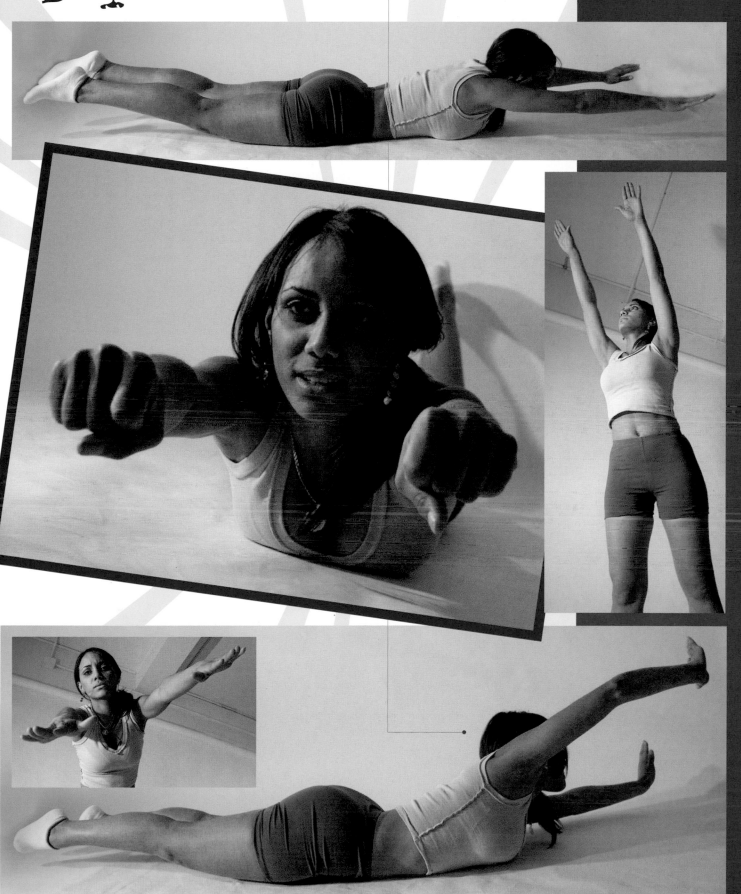

White Man

MATT HALEY **demonstration** ON PAGE 87

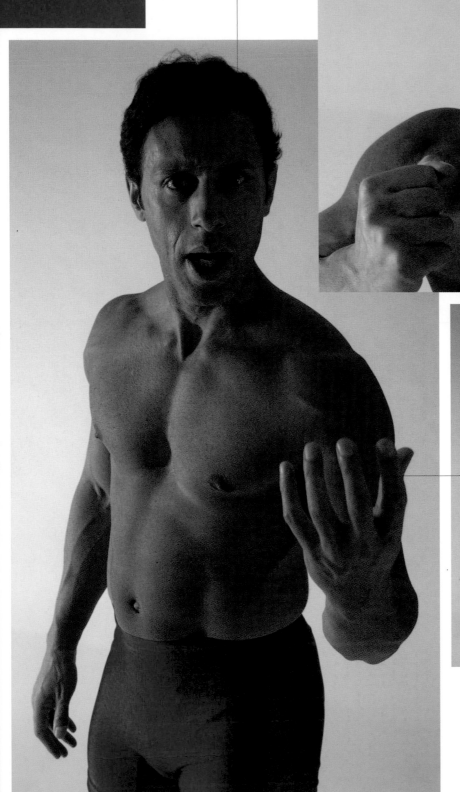

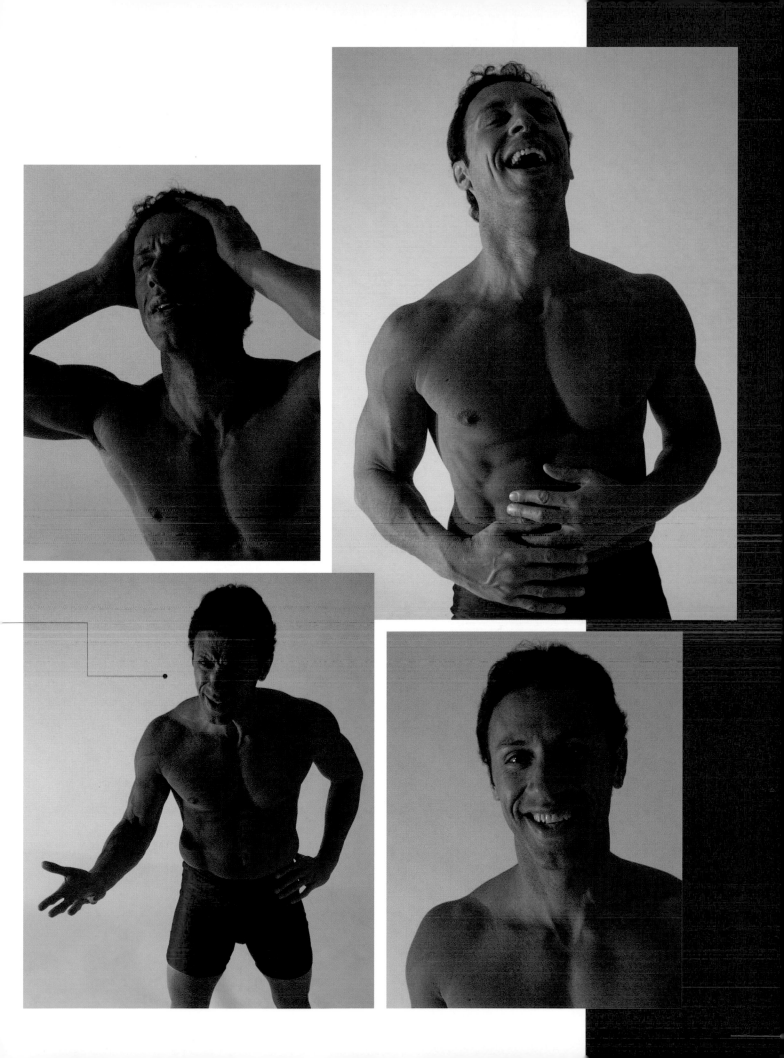

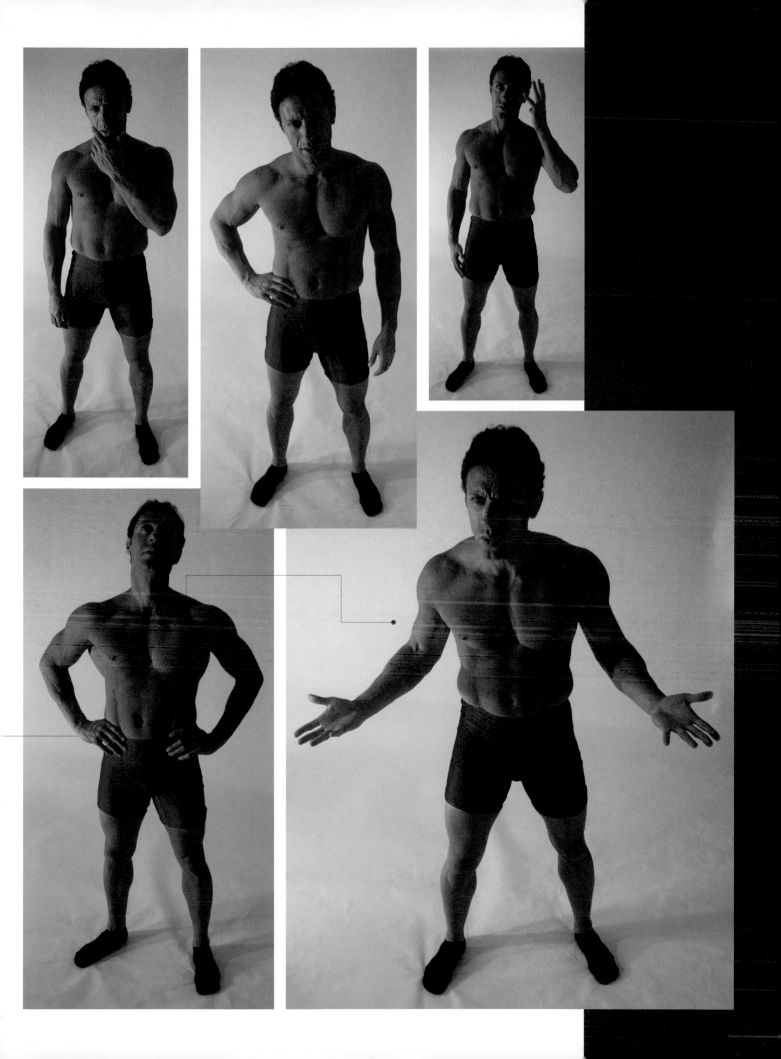

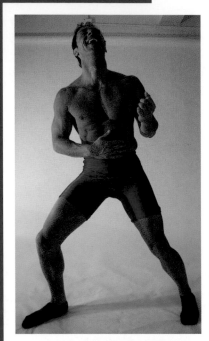

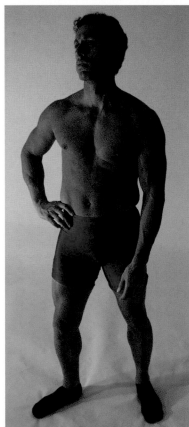

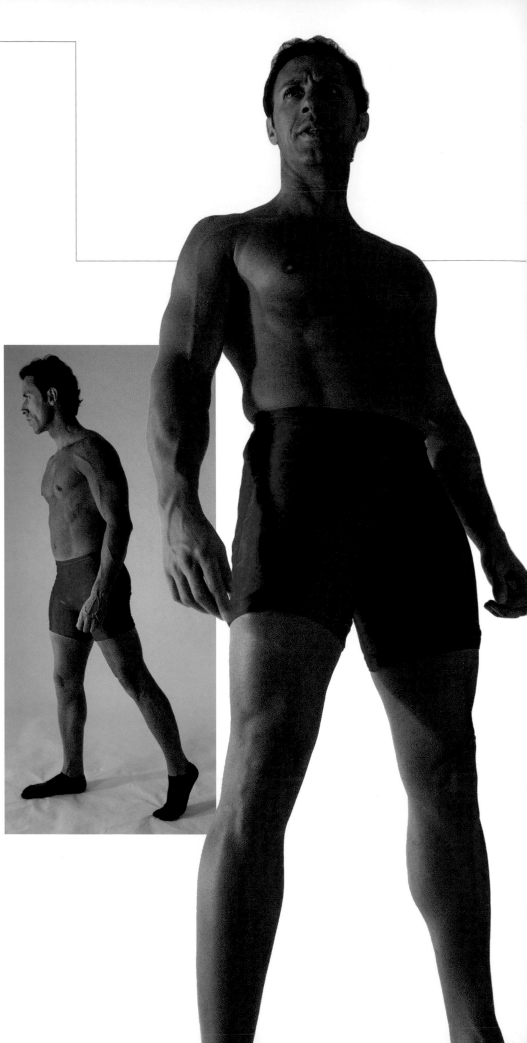

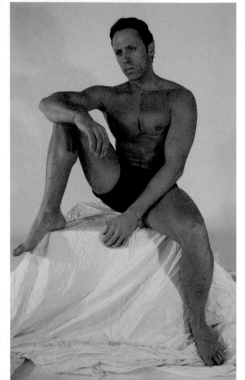

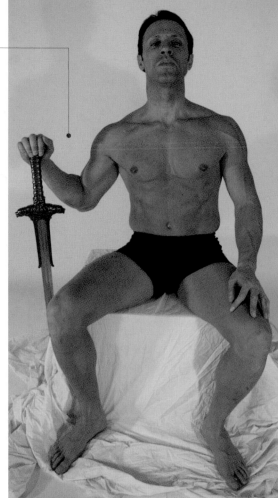

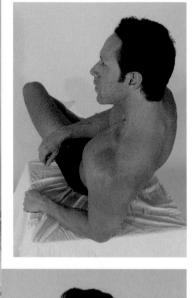

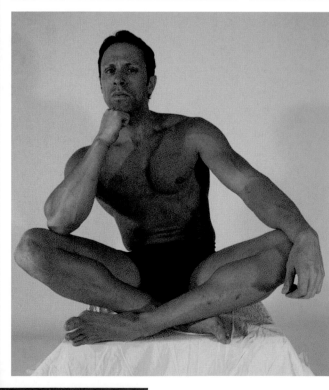

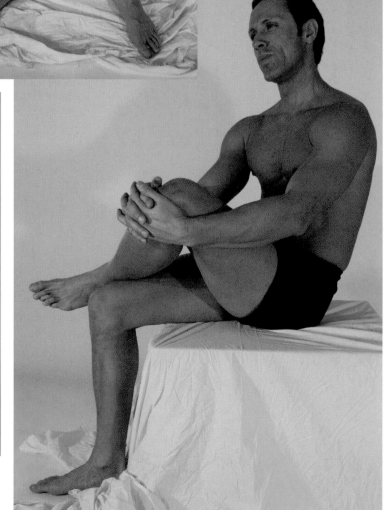

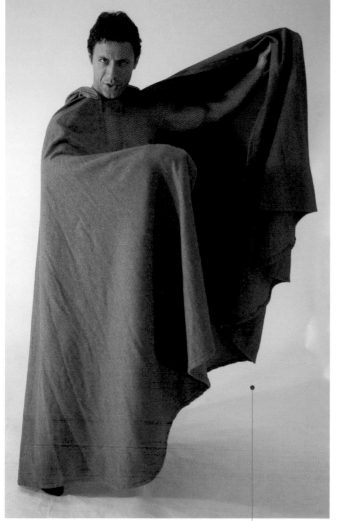

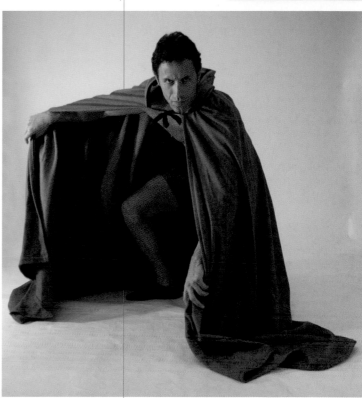

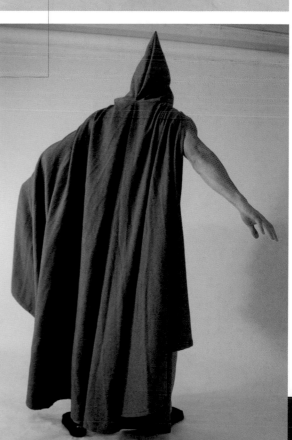

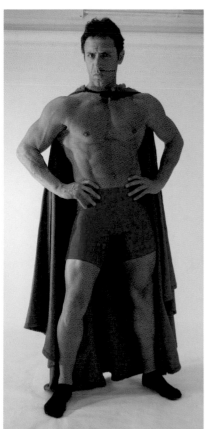

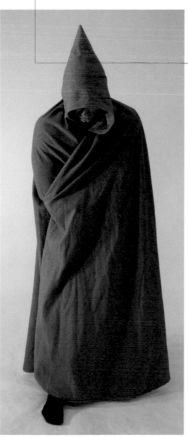

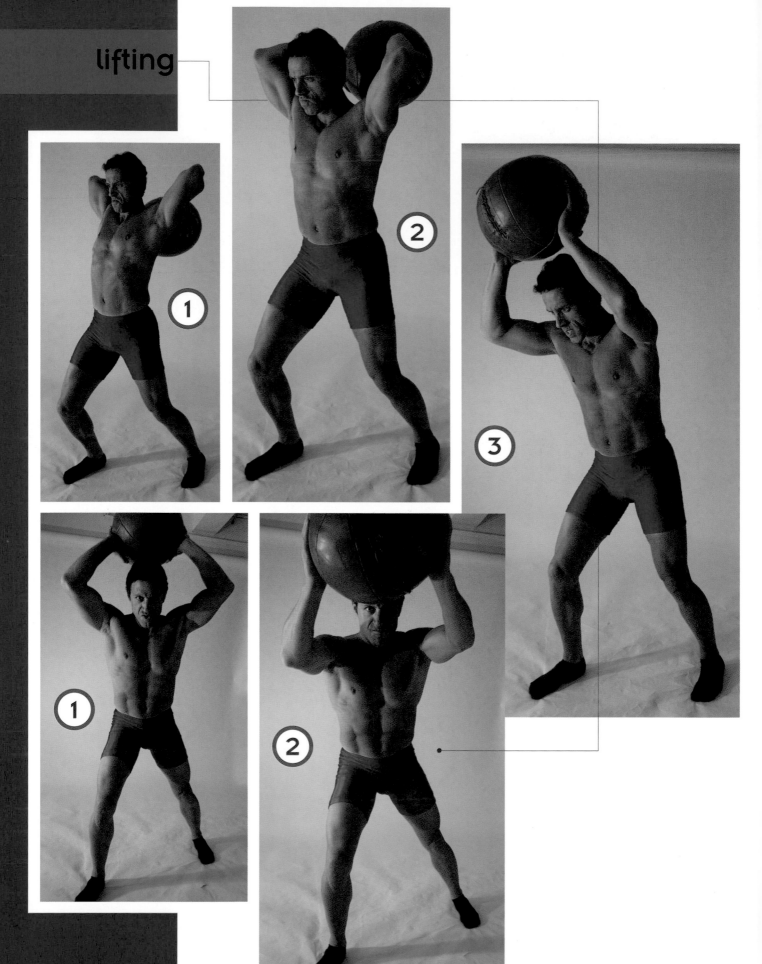

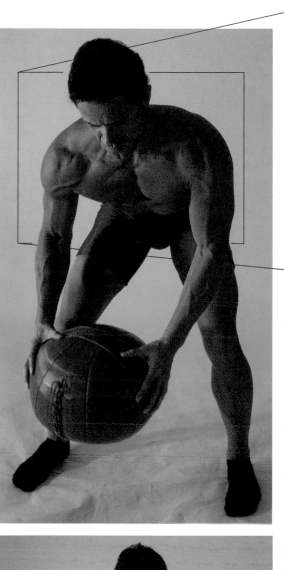

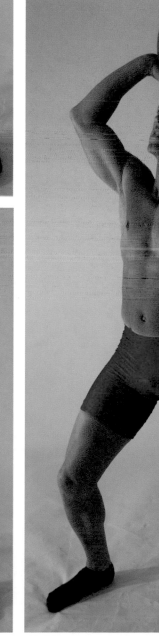

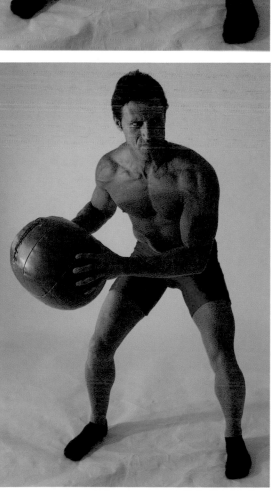

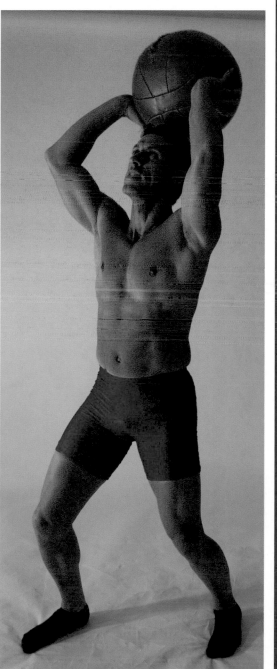

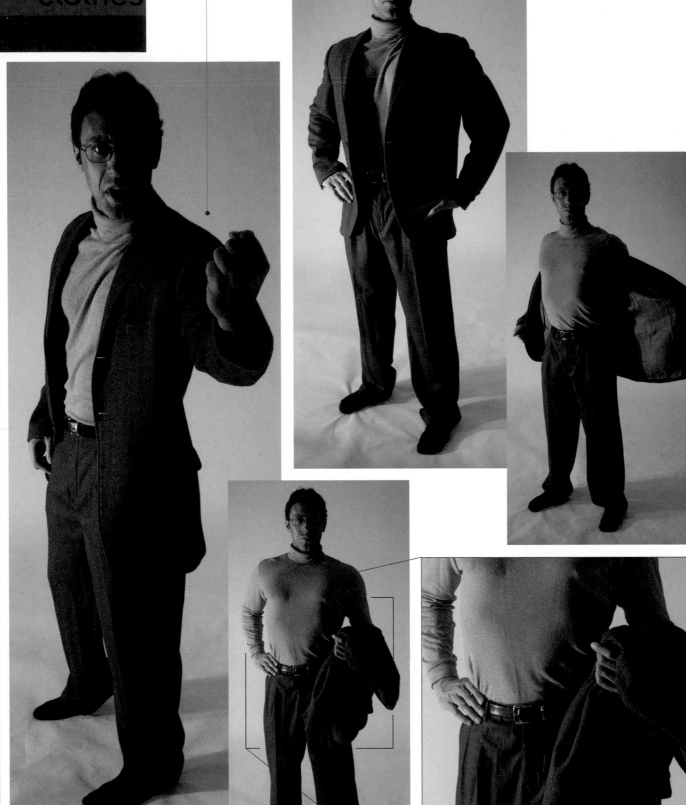

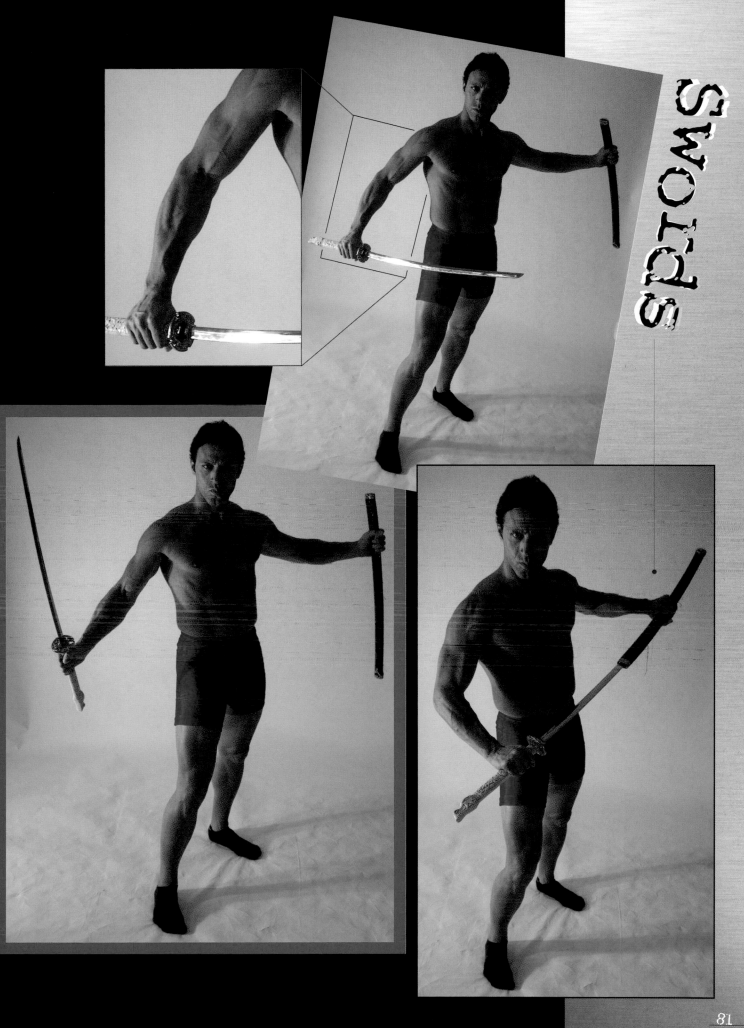

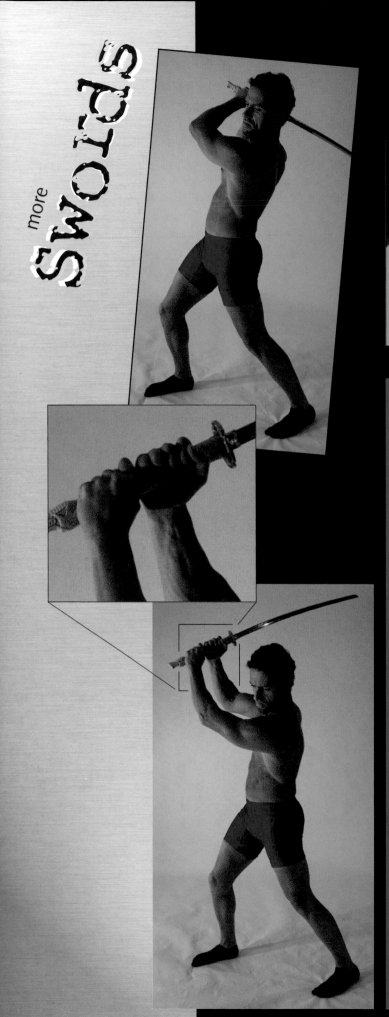

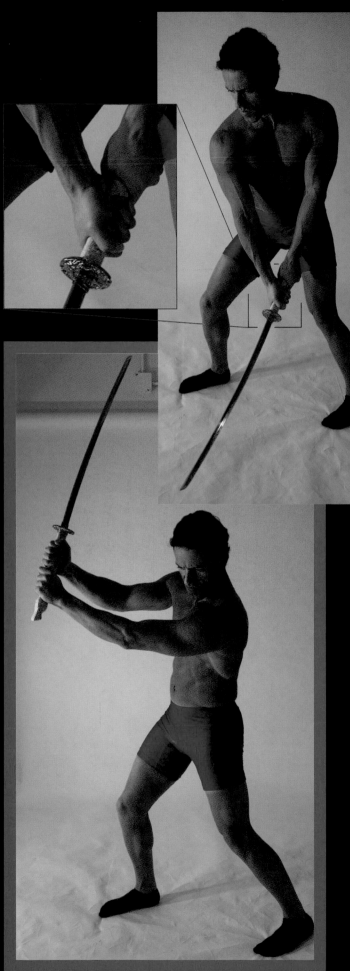

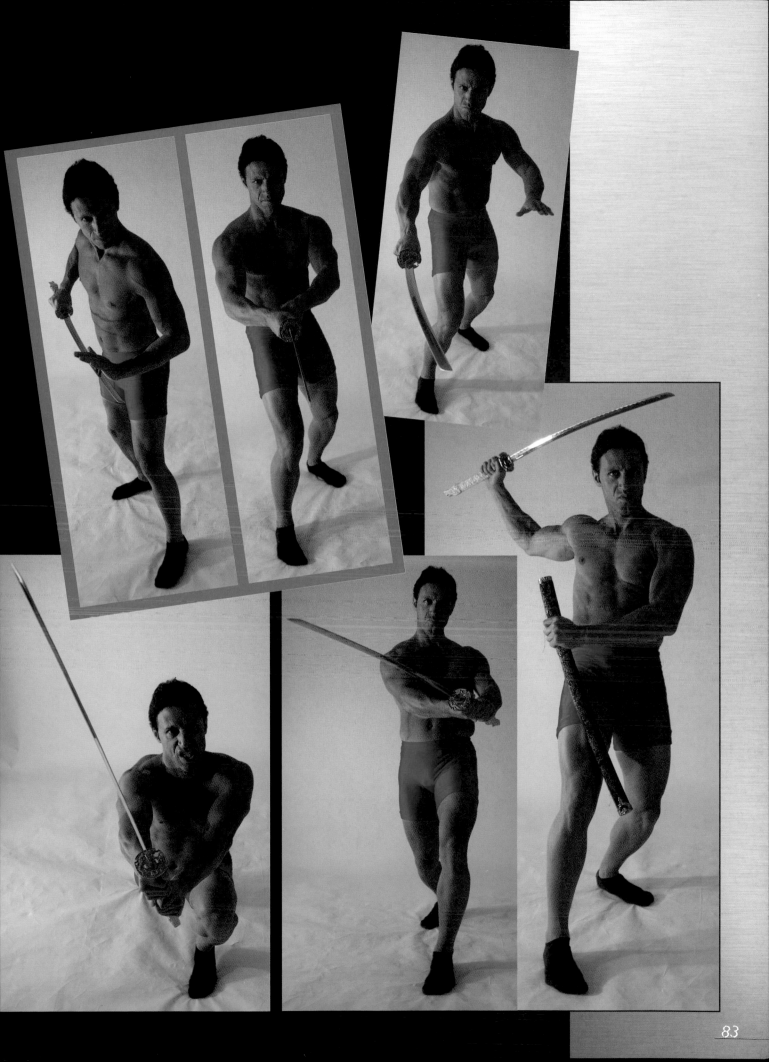

Guns

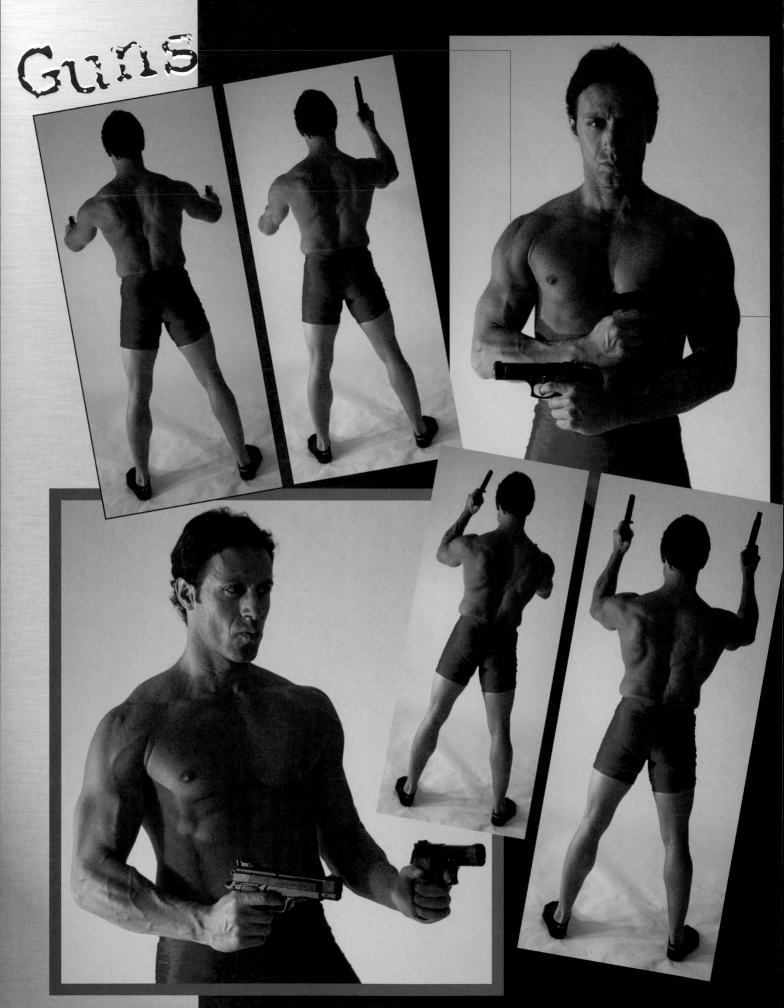

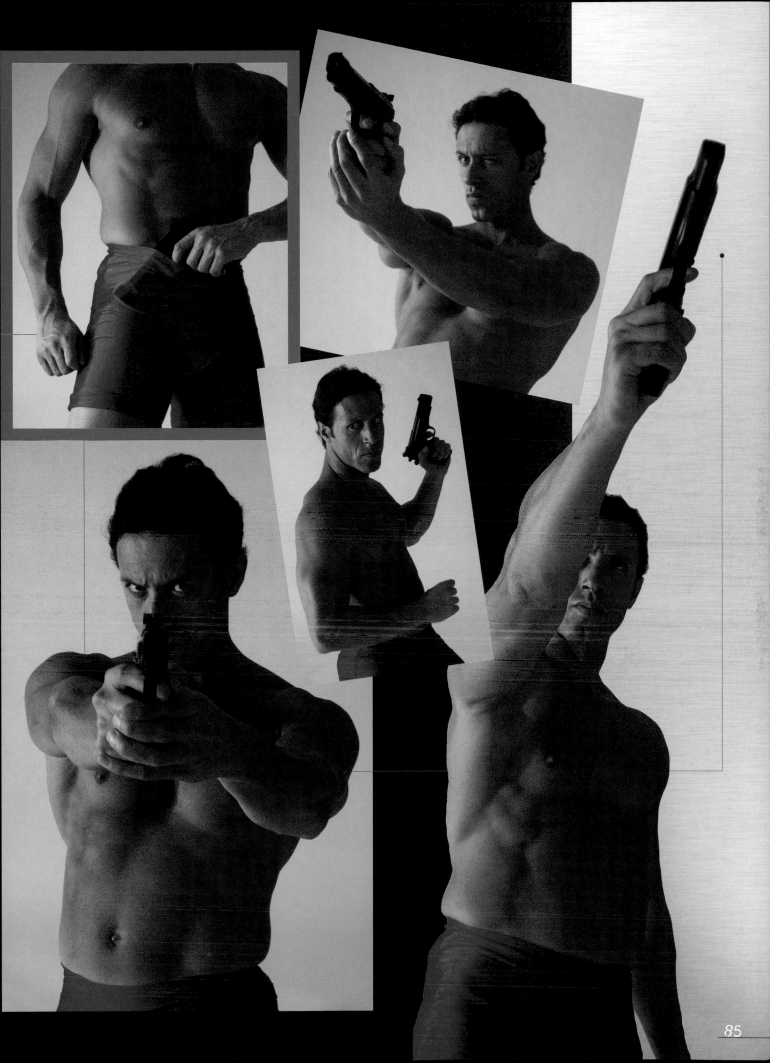

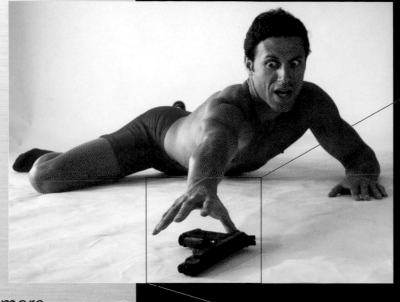

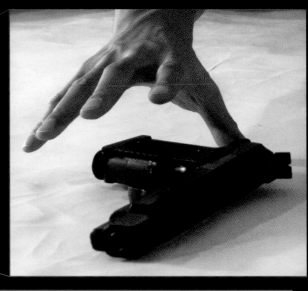

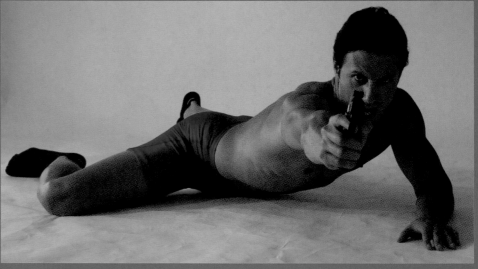

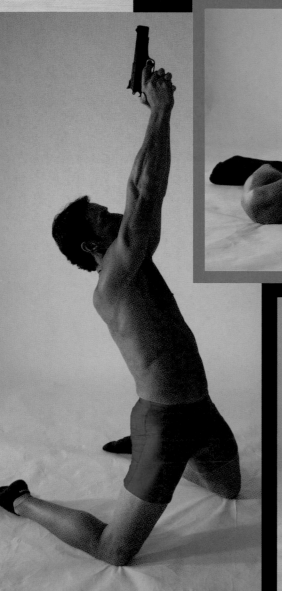

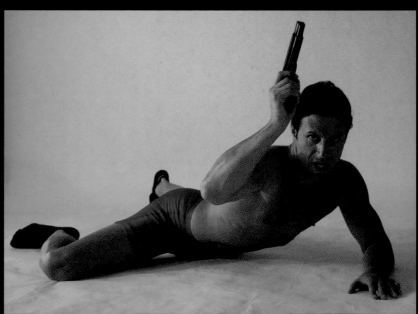

The Body in Motion

BY MATT HALEY

One of the challenges of drawing comics is that you are often called upon to imply motion on flat paper. When you rely too heavily on photo reference, your art can appear motionless—like a photo. Learn how to interpret photo reference so you can create something original and dynamic.

A lot of artists draw the easy pose to get the page done. Sometimes it's difficult to draw what best serves the story, but that's what you have to do.

Sketch Broadly

Make a quick sketch using broad strokes. If you hold the pencil as if you were writing, you'll get very little movement at the tip of the pencil. This is good for detail work, but at this early stage, you want to hold the pencil like a stick. Slash a line from the head through the spine. This will suggest the direction in which the figure's body is moving. Don't worry about the details right now; you want something free and fluid. You could do this step with a nonrepro blue pencil, since it won't smear and it won't reproduce on the final art.

Pick Your Photos

Look for a photo that has a dynamic pose. This picture has some forced perspective; the limbs look like they are coming right through the photo. Remember, the photo does not have to be an exact shot of what you plan to draw. You're not going to be tracing; you're going to be drawing with the photo as a reference for structure and certain details.

The gun reference comes from a different photo.

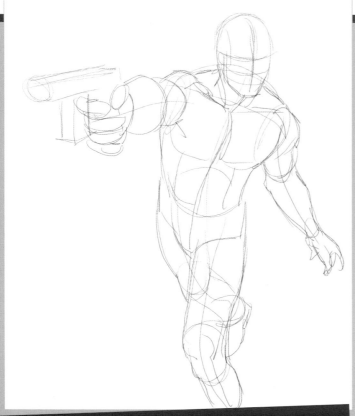

Rough Out the Figure

Using the lines you made in step 2, rough out the form of the figure using cylinders, cones and spheres. As you do this, it's very important to draw through (see TECHNIQUE below). Even though you don't see the model's back leg in this picture, draw it anyway. If you draw only one leg, your figure may appear off balance, and it will be difficult to fix later. Your rough should also include basic foreshortening of the receding lines. Notice how the model's right forearm looks stubby and compressed. Foreshortening suggests depth and distance to the reader, who knows approximately how long the arm should be based on the length of the other arm. The art is already starting to evolve away from the photo.

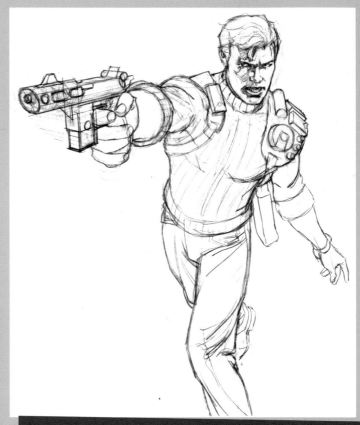

Draw the Figure, Then Dress It

Refining the contours of the figure and adding clothing is a two-step process. First draw the anatomy without any real clothing other than the snug-fitting clothing the model in the photo is wearing. That way you're able to see the anatomy clearly and draw it accurately. Now, just as you do in real life, put the clothes on. This two-step process will help you to understand how the clothes should fold and drape.

If you start with a silhouette and then just throw clothes on the figure, it will appear as if the clothes are part of their anatomy, which just isn't the case. We exist as humans, and then we add clothes. Learning how to properly draw the folds and draping of clothing requires a lot of practice, so don't worry if you don't nail it the first time.

TECHNIQUE

drawing through

Drawing through means adding lines to represent all sides of a form, even the sides that aren't visible. Drawing through adds weight and depth and helps you capture perspective and form more accurately.

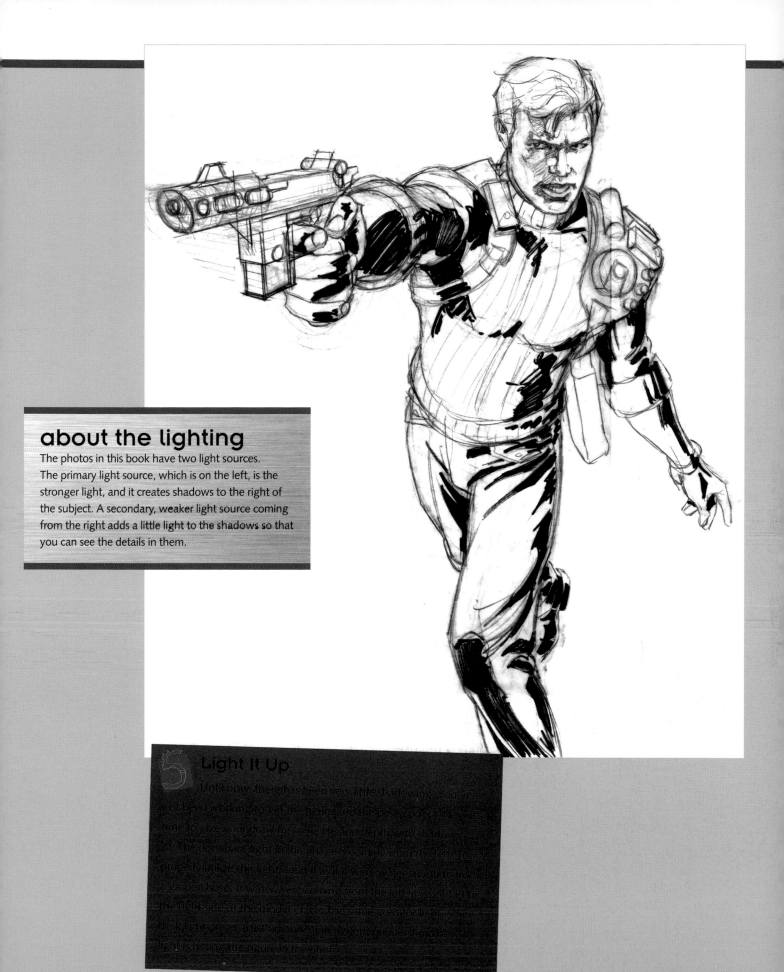

about the lighting

The photos in this book have two light sources.
The primary light source, which is on the left, is the
stronger light, and it creates shadows to the right of
the subject. A secondary, weaker light source coming
from the right adds a little light to the shadows so that
you can see the details in them.

5 Light It Up

Until now, there has been very little shadowing. You've
just been working to get the figure and the background in. Now it's
time to give your drawing some life and depth with shadows.

The dominant light in this image is coming from the left. To
properly utilize this light, treat it as if it were water shot out from
a garden hose. If water were coming from the left, it wouldn't hit
the right side of the model's face. The same goes for light. A quick
desk light on an artist's mannequin lets me understand just how
light is hitting the figure in the photo.

6. Add Detail and Background

This character is going to appear slightly behind the main character, but you should draw through the entire figure on a separate page.

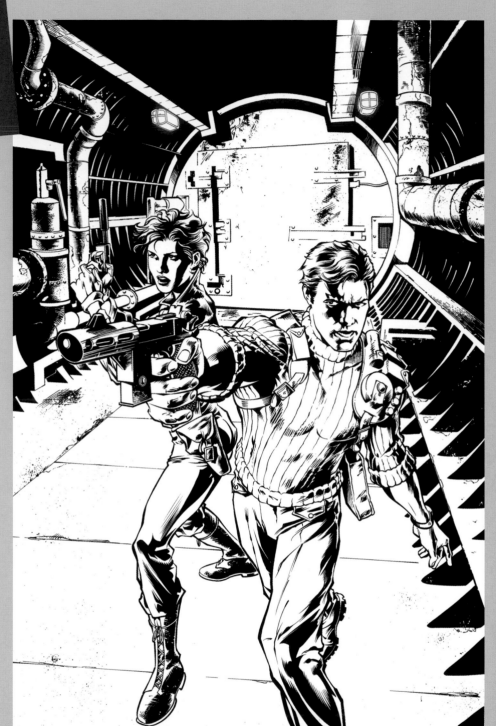

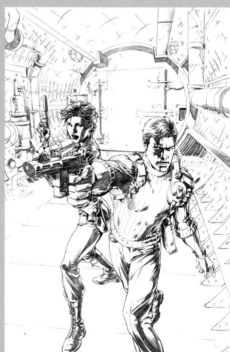

Use a light table to insert the female character behind the male one. Rough out your background so that you have a sense of proportion and perspective.

Inking makes the whole illustration come alive with contrast. Ink the blacks, referring to the photograph again to confirm the direction of the light.

Once the art is inked, it is difficult to change it back.

tip

When combining two or more reference photos, try to find photos with similar light sources.

The Finished Cover

Now that the color and logo have been placed, notice how this image controls your eye. You want something eye-catching in the top left corner to draw the eye into the Z pattern (see TECHNIQUE on page 48). This is where many publishers place a logo. Notice how the eye travels from the logo to the woman's face, up her hair to the title, and down the right side of the circle. The circle guides the eye to Jack's face, out his arm to the gun, down the woman's body, to her right foot, right into Jack's body, up the vertical lines of his sweater and back to his face . . . right where we want it. The fully colored art with logos draws the reader into the image.

A photo is a jumping-off point that you can use for inspiration and reference. But at a certain point you need to put it away so that you have room to change your image as you draw.

Fighting

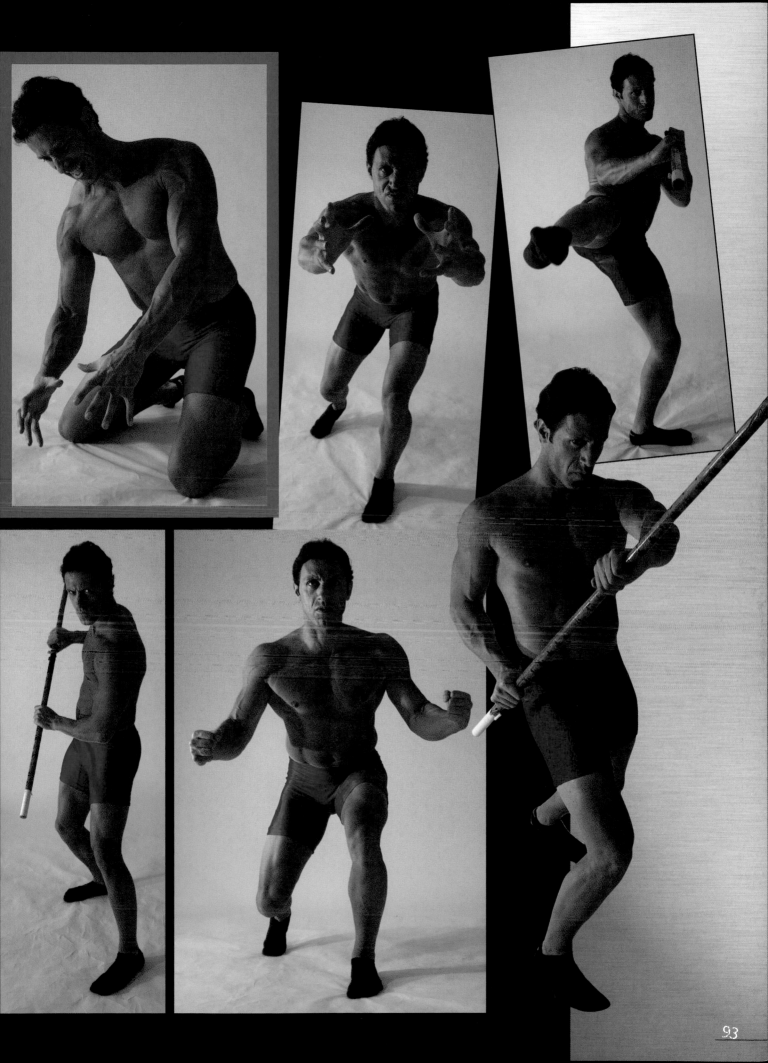

wounded

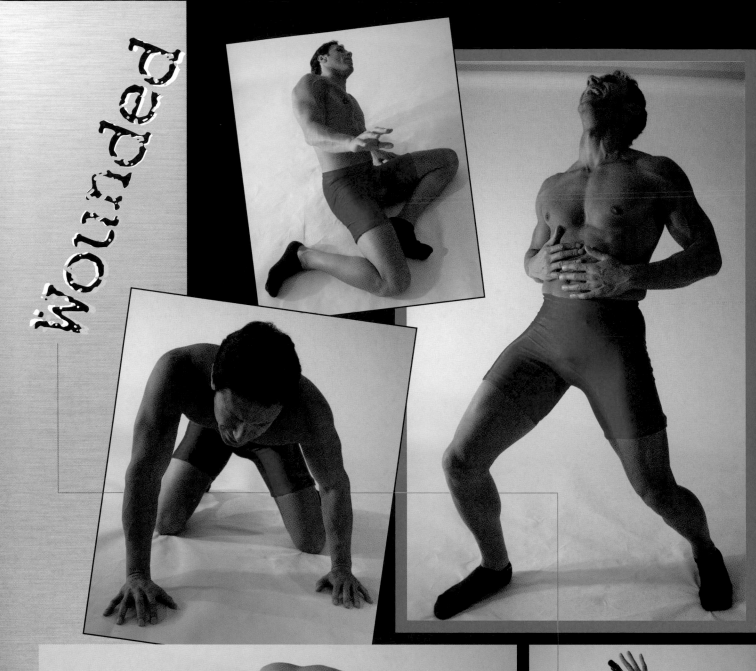

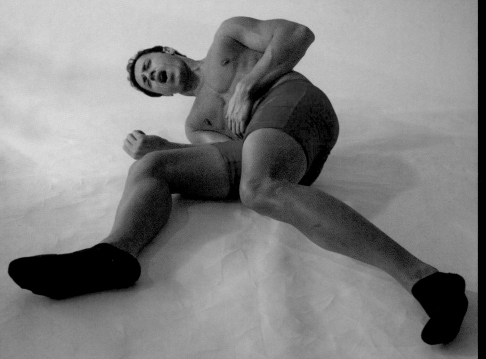

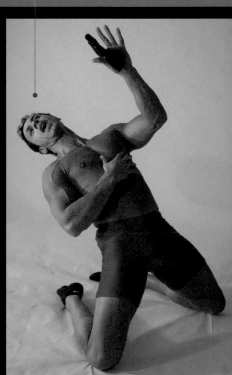

94

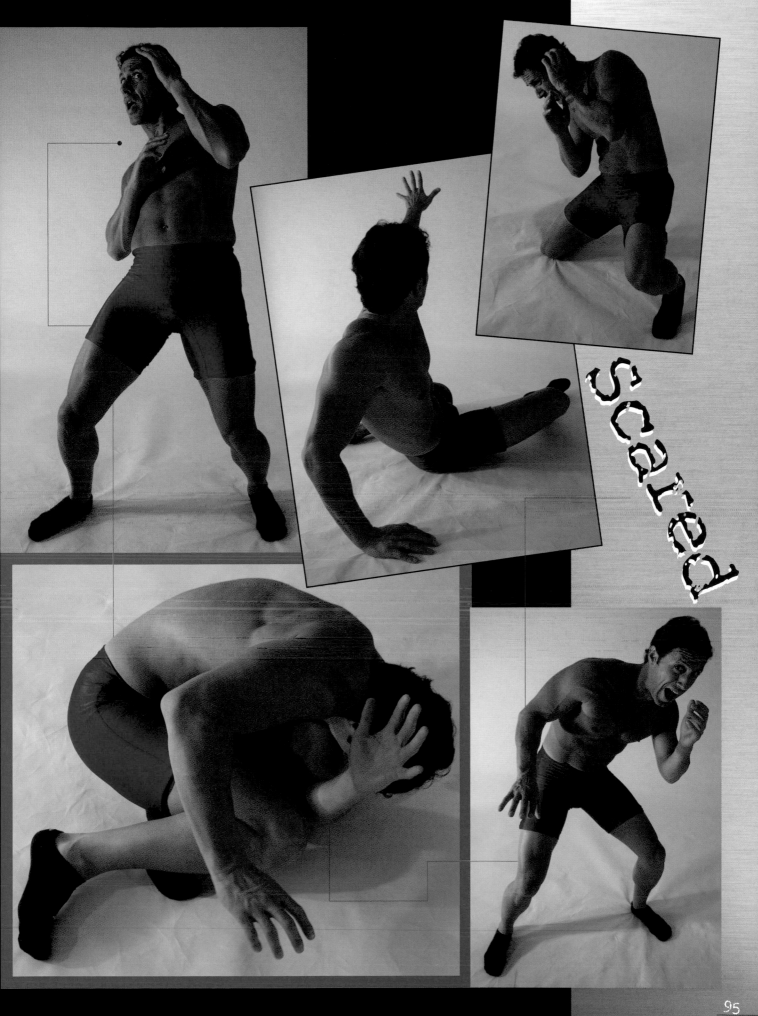

scared

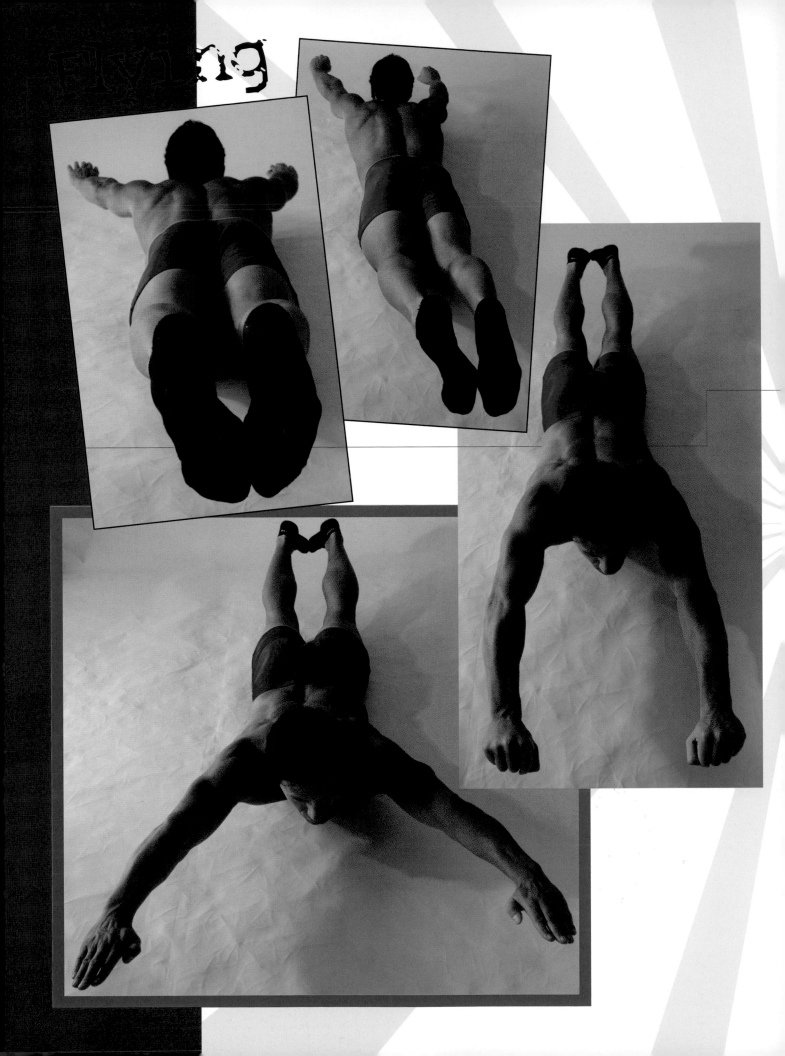

Flying

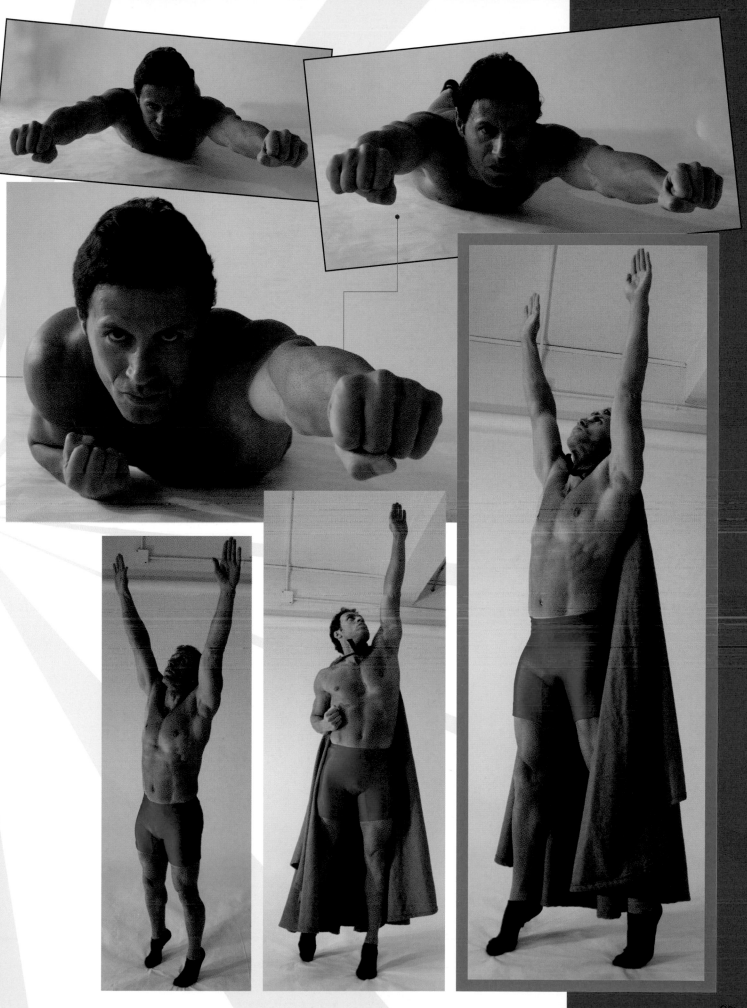

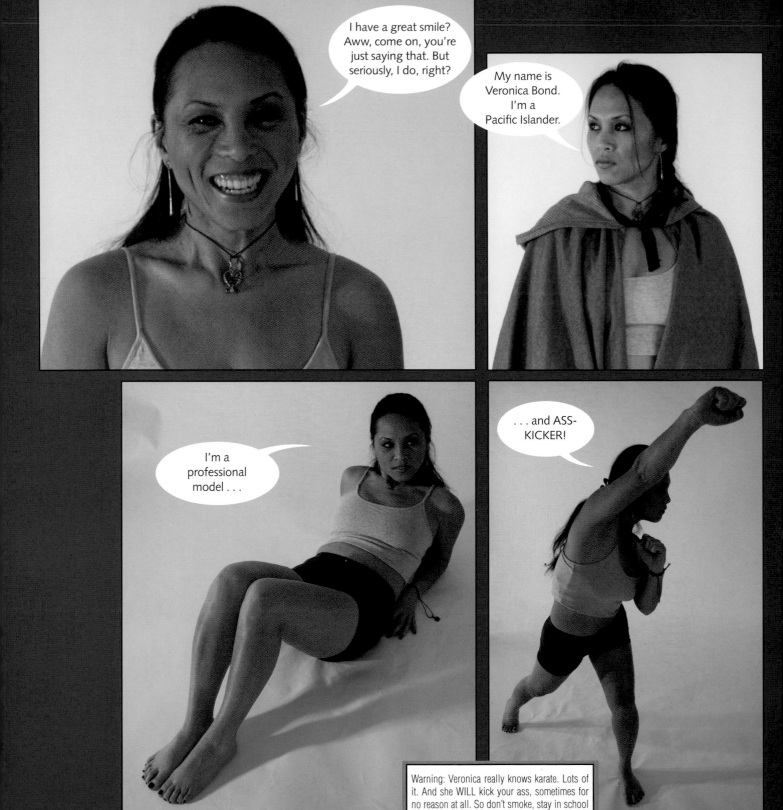

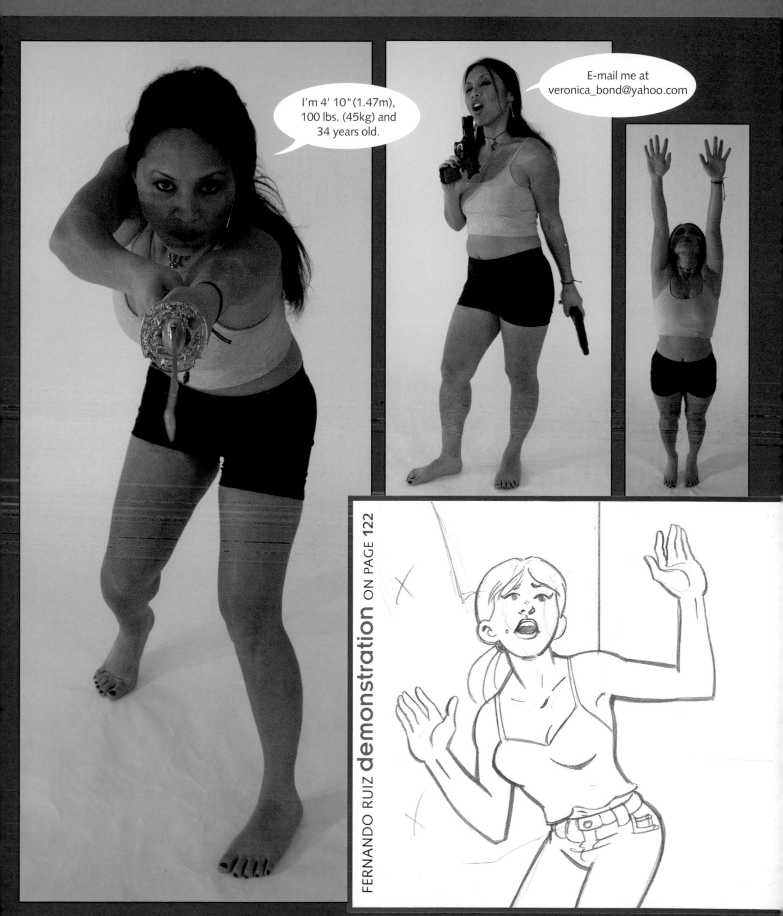

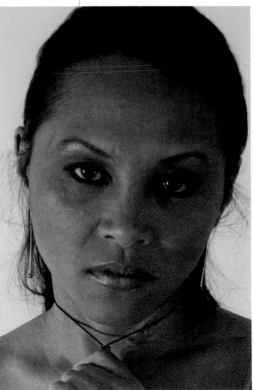

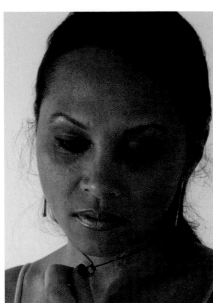

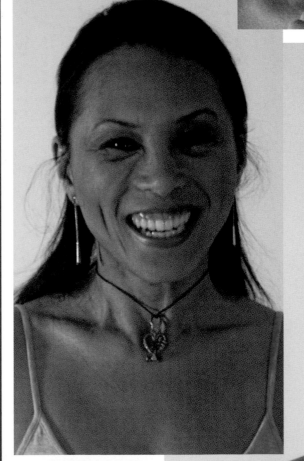

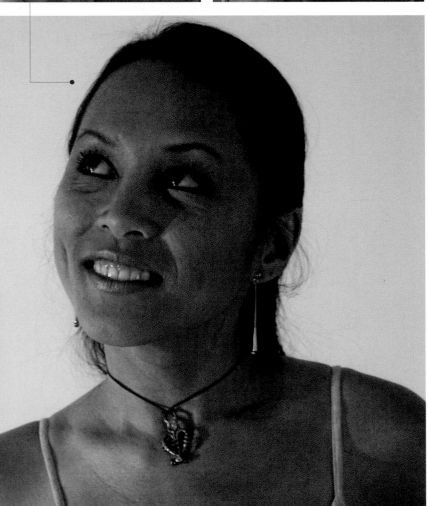

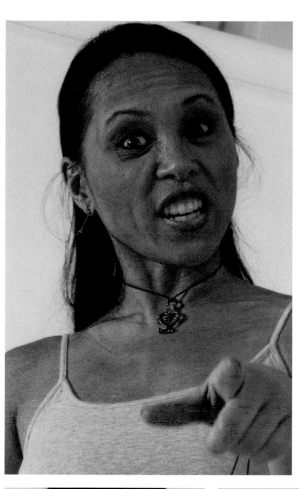
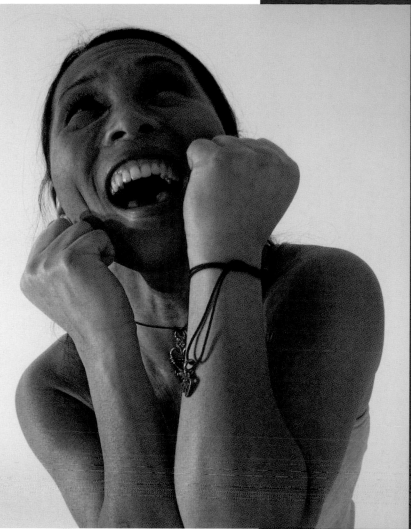
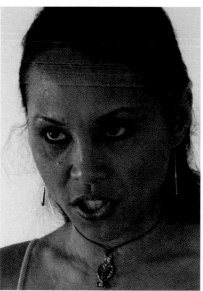
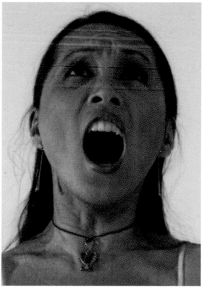
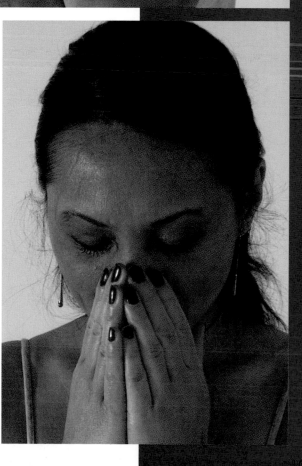

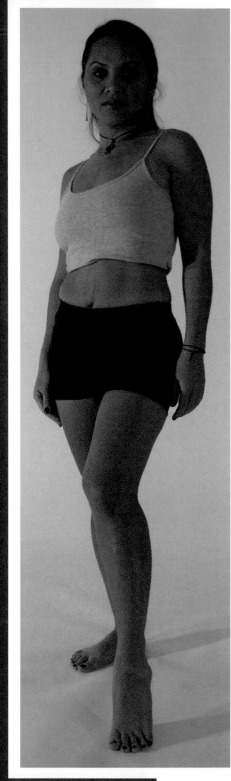

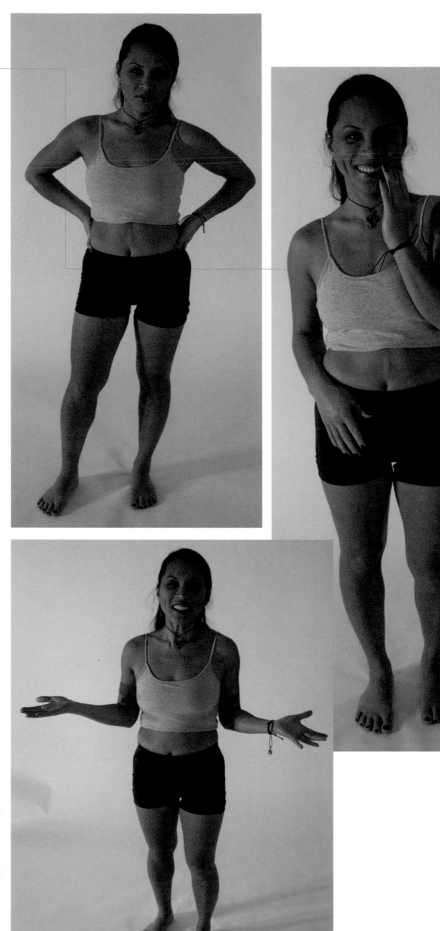

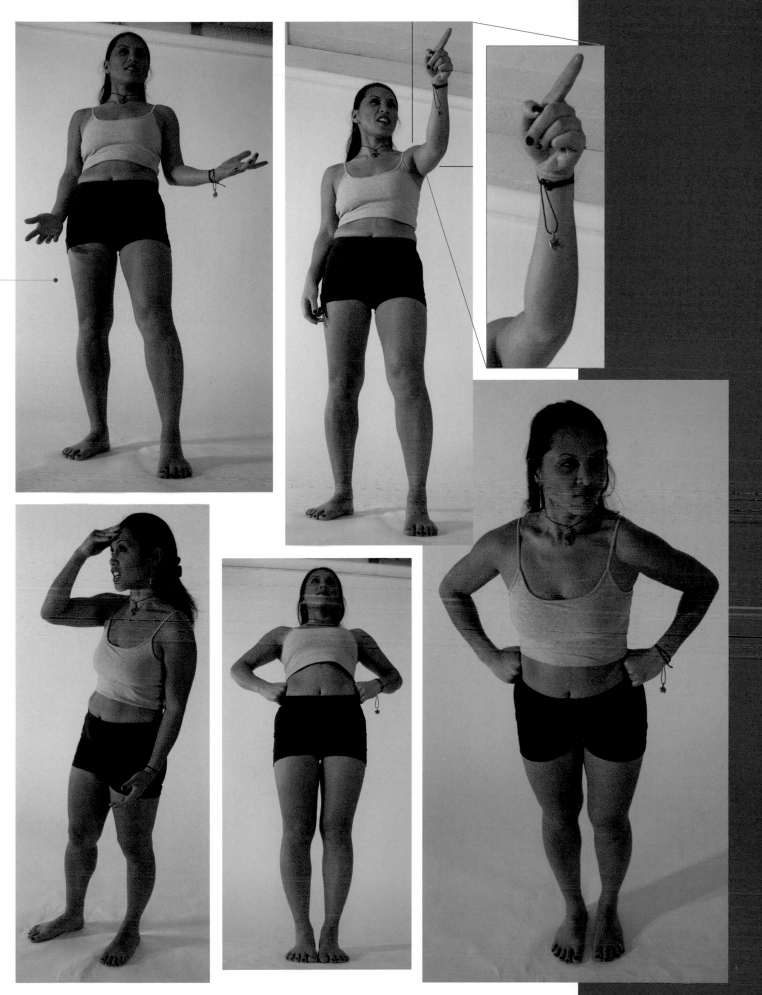

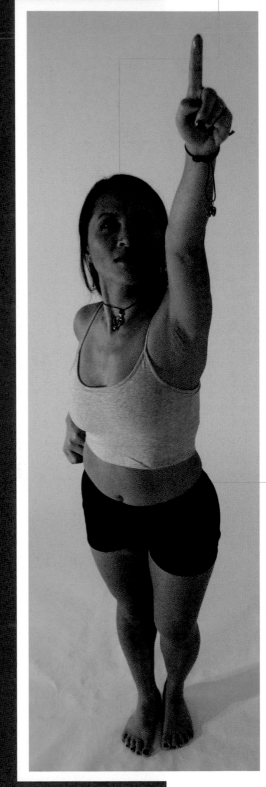

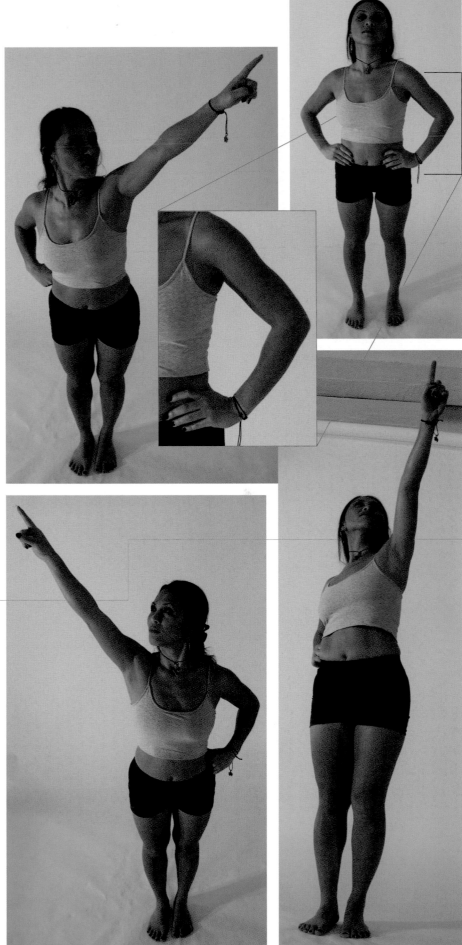

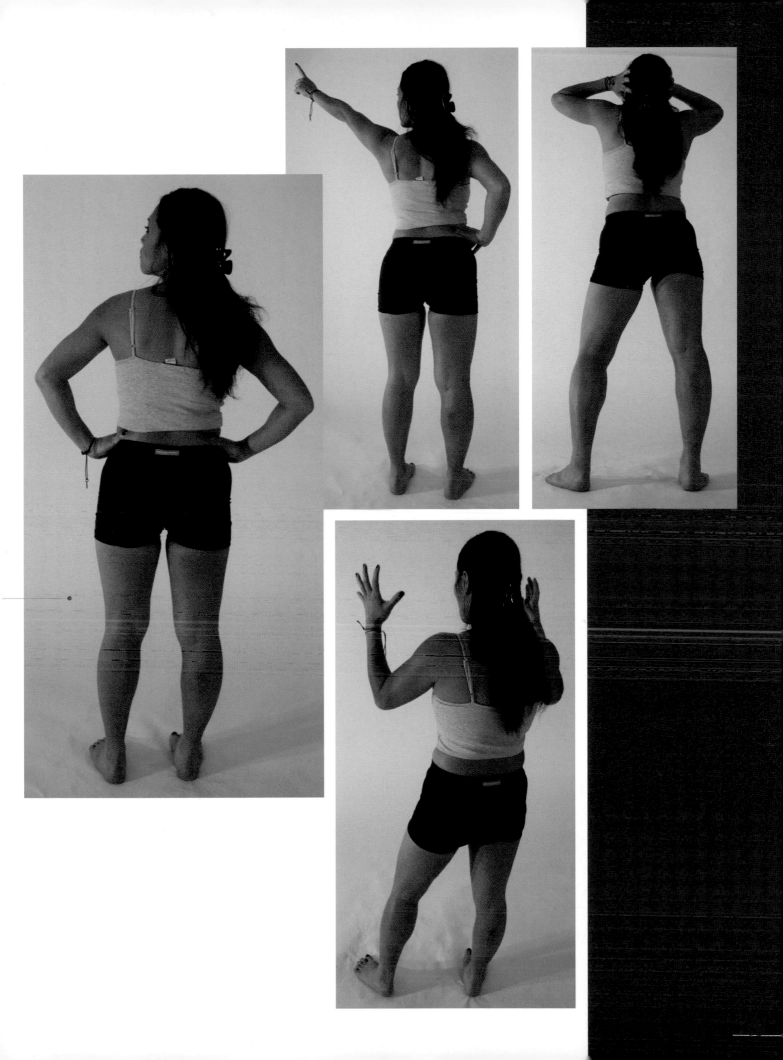

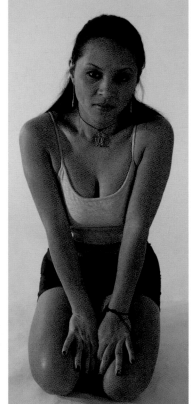

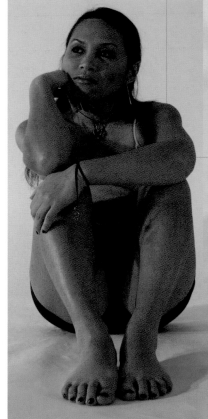

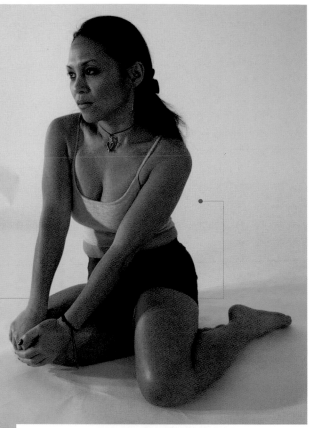

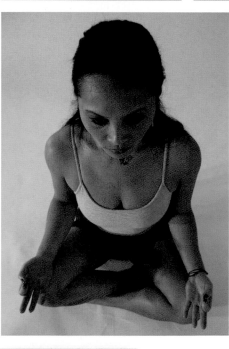

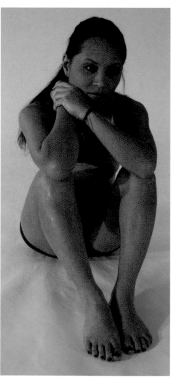

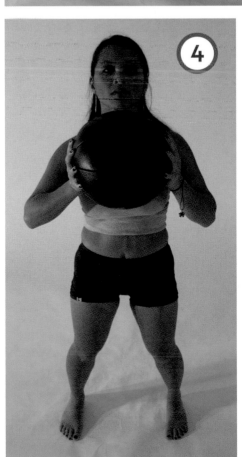

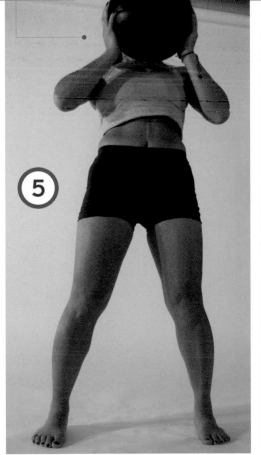

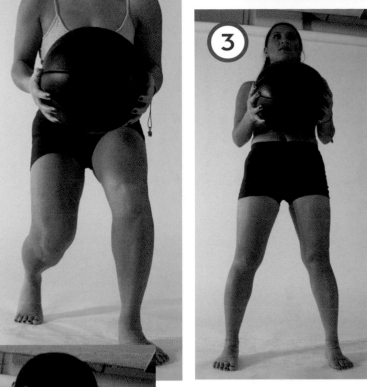

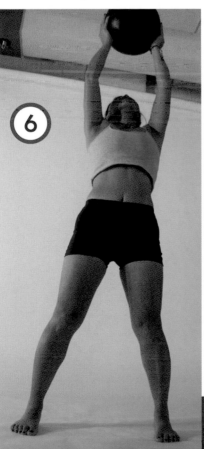

cape

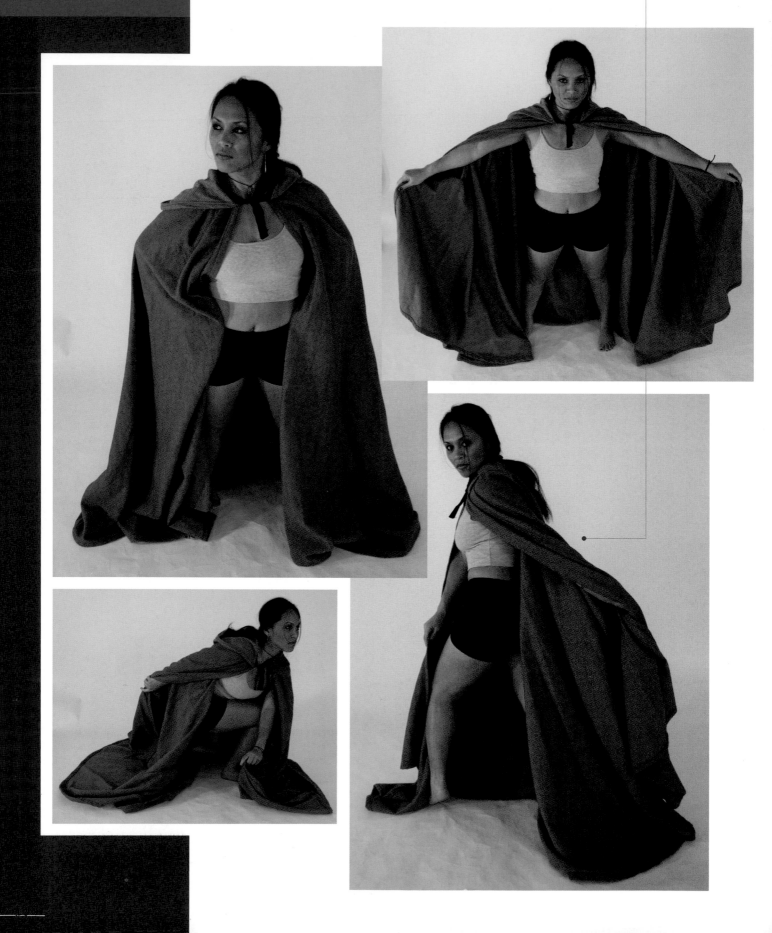

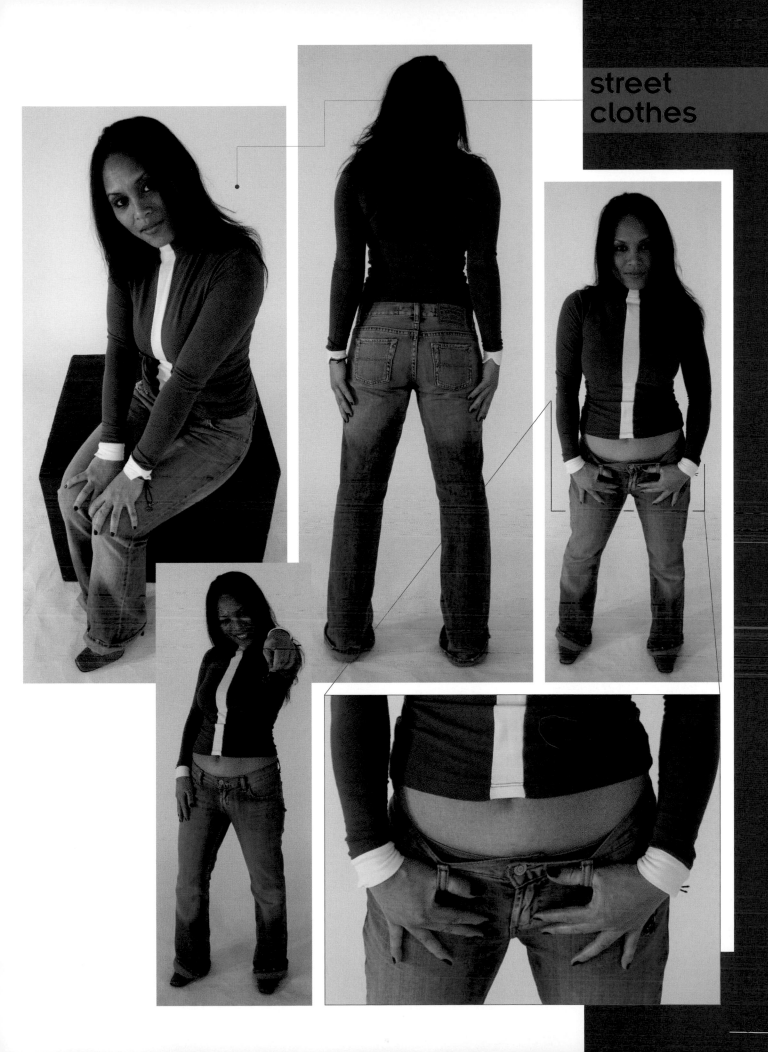

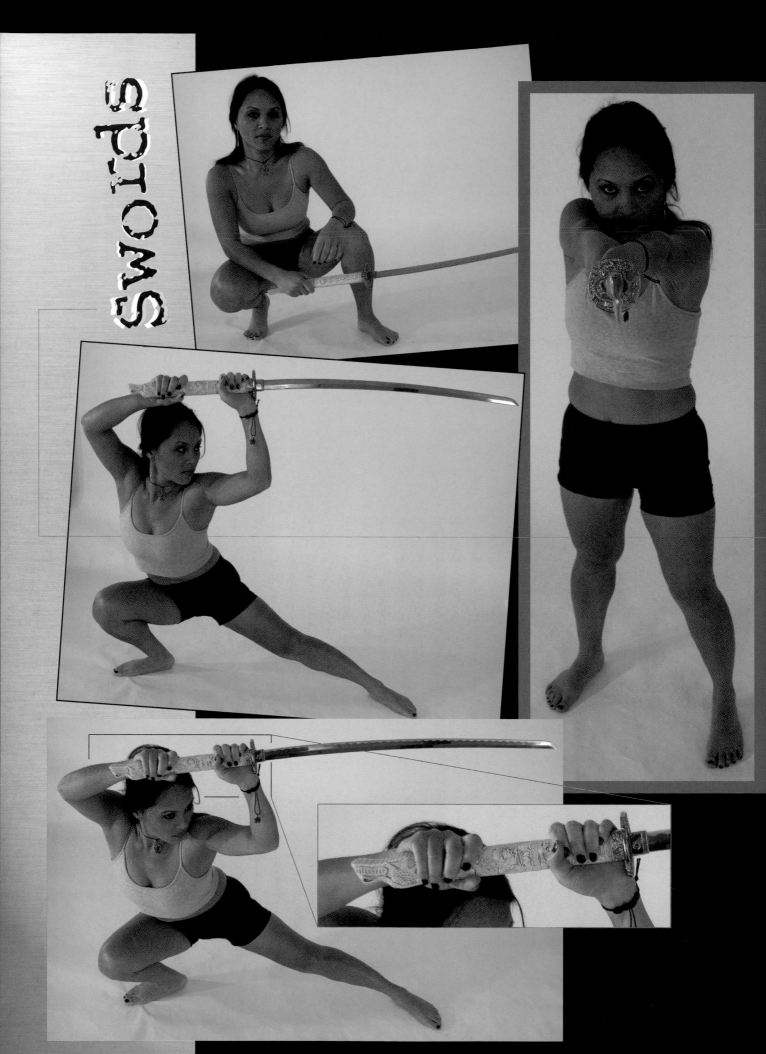

Swords

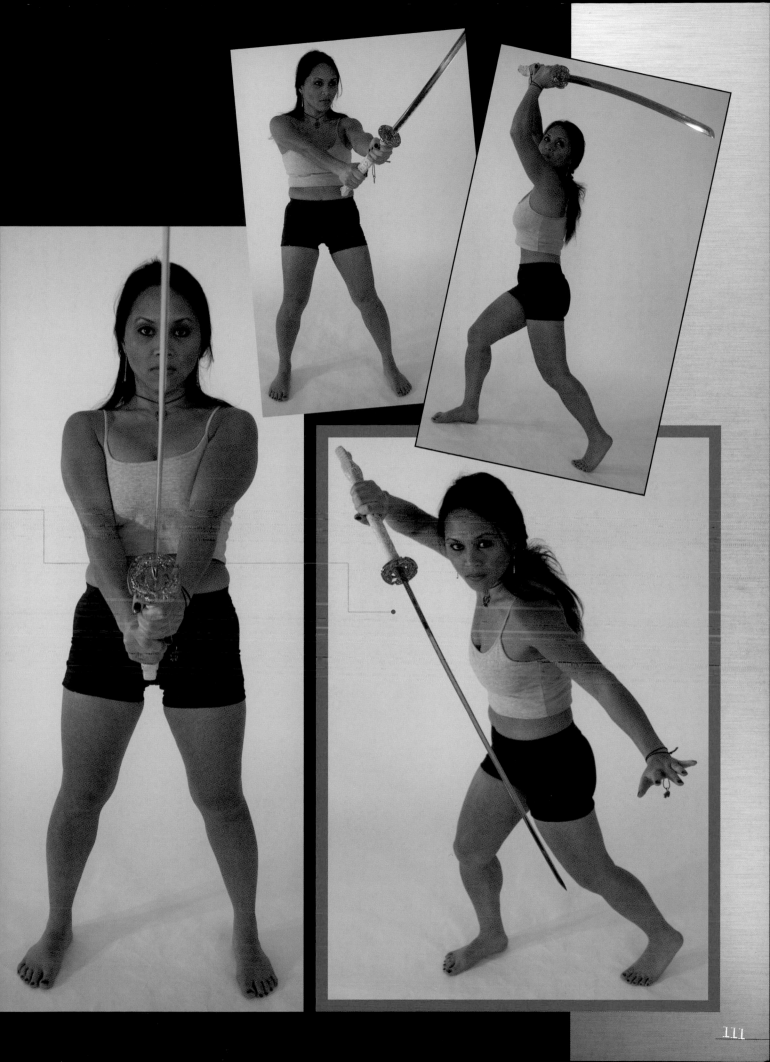

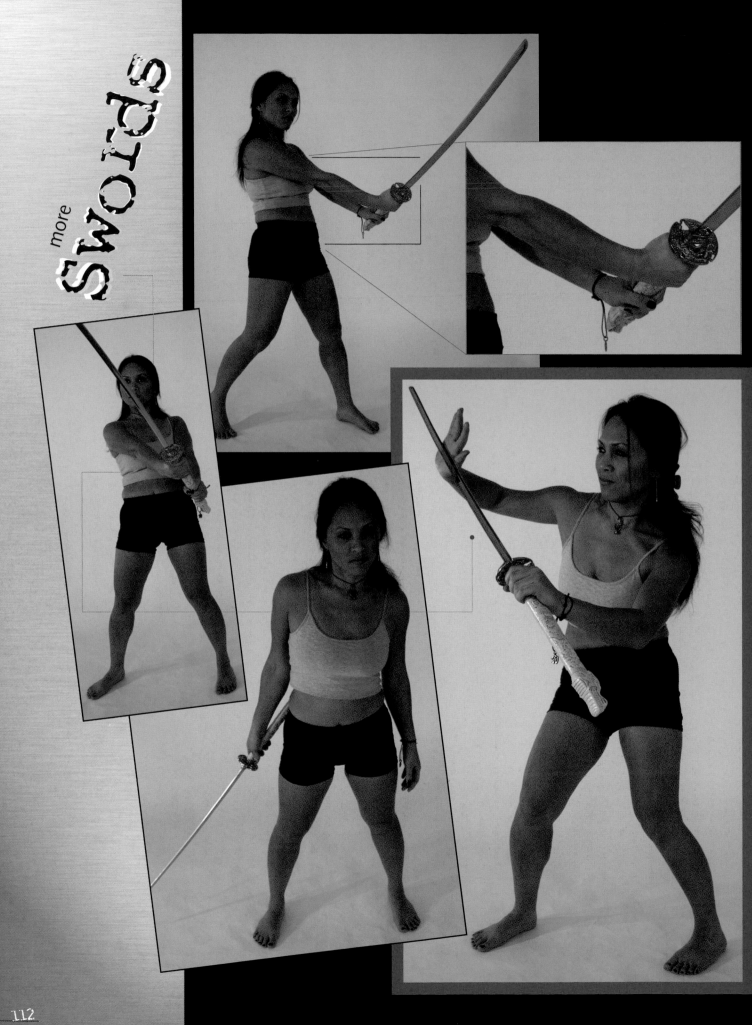

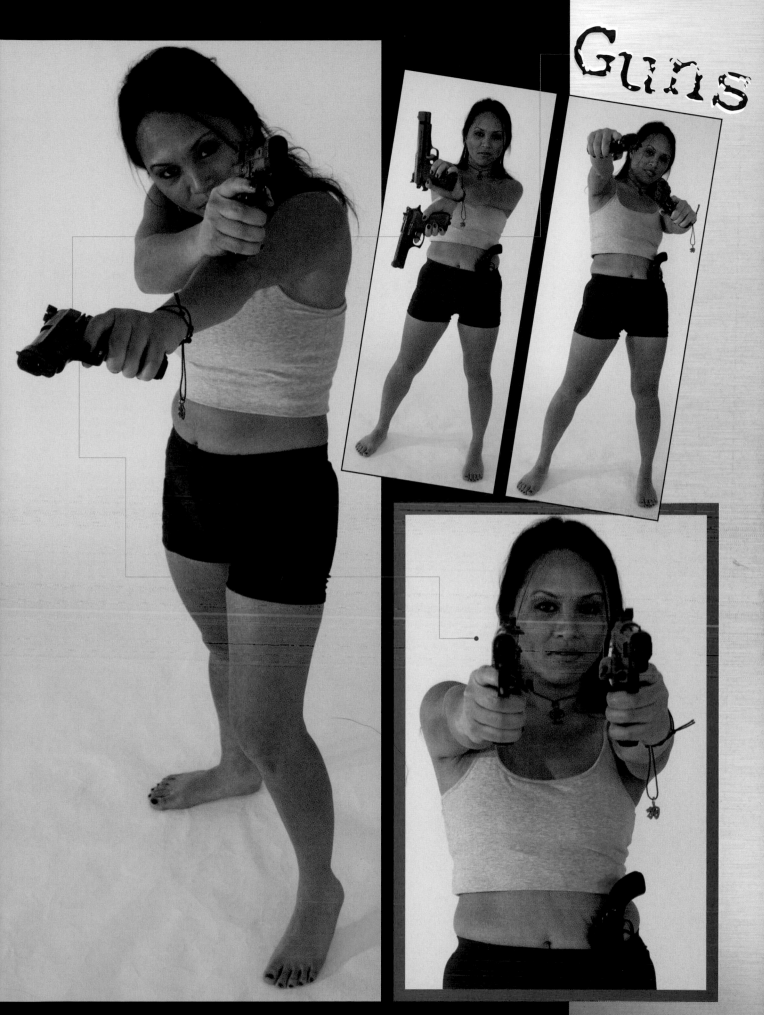

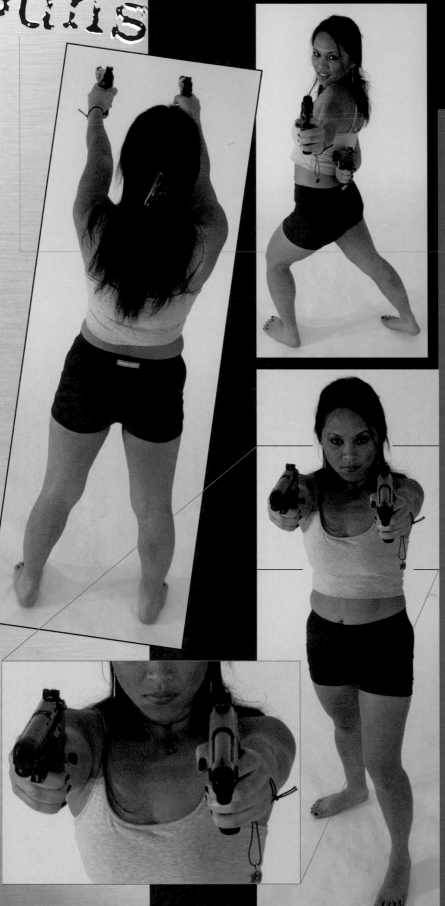

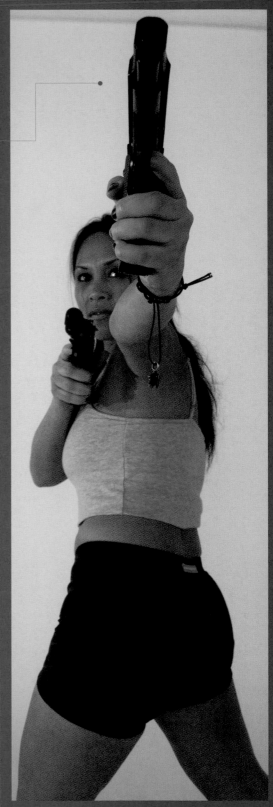

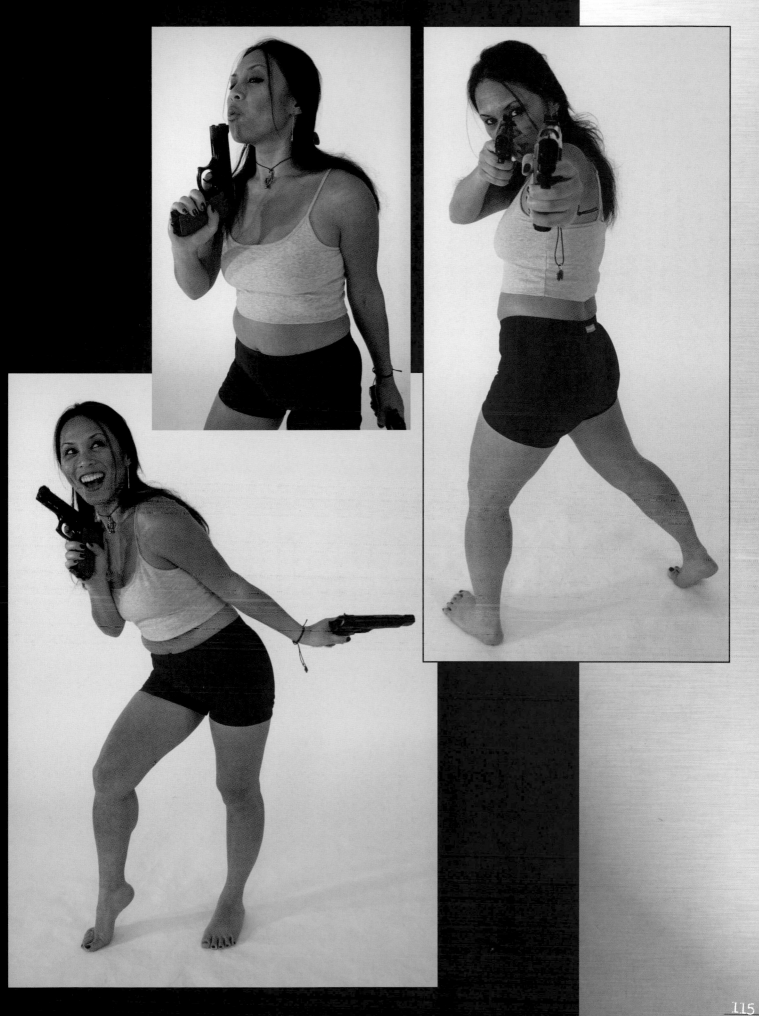

Demonstration

tip

Hold your drawing up to a mirror. This tactic gets your mind out of "drawing" mode and into "reader" mode, giving you a fresh perspective on your art.

Draw a Character on a Background

BY PAUL CHADWICK

Comic book artists use photographs as a starting point to create a visual story in one or more panels. Most reference is photographed in a studio with simulated daylight conditions. Creating a nighttime scene in an exterior setting requires imagination and maybe some additional photo reference.

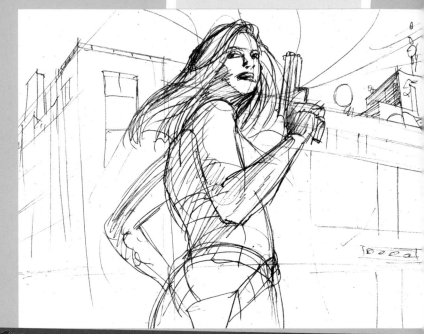

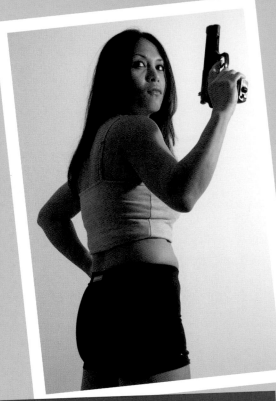

2 Rough a Sketch

Make some rough sketch lines to get a sense of perspective and proportion. Don't worry about getting the anatomy and pose perfect at this point; you are just trying to see how these separate pictures can be merged. The figure and the background exist in two different three-dimensional worlds, and all you have to work from are two-dimensional representations of those worlds. So in your head, figure out how far this person is from the building. Based on the width of the sidewalk and the photographer's position in the street, this person would be at least 30 feet (9m) from the building. The head is placed slightly higher than the roofline to control the eye and to keep the focus on the character.

Don't overlook opportunities to change hair and clothing. The model in the photo has straight hair that hangs down. Instead, you can draw the hair with a windblown look to add motion, life and realism to the static pose.

1 Find Your Photos

Look for photos with a pose and background that tell the right story, even if the lighting will have to be changed. The female model here is in a striking, dramatic pose from a slightly low point of view, which gives her a sense of imposing power. Note the strong light coming from the right side.

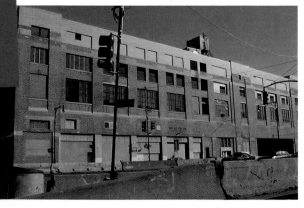

The warehouse photo is from the CD-ROM *Visual Reference for Comic Artists: Vol. 1* by Buddy Scalera. For more details, see the "About" section of the CD-ROM that accompanies this book.

Tighten the Sketch

3 Begin to tighten both the background and the figure. Use a ruler to create the rigid lines of the building. Add repeating elements such as windows and doors; their angles help create a sense of distance and perspective. The perspective lines radiating from the peak and corner of the building point to the center of the image, which directs the eye to the figure. Add small details to the background that will add realism without distracting from the visual story.

Once you have the basic figure roughed out, add costume details. Snaps and buttons make nice repeating images on your character. When adding details such as belts and holsters, be sure to observe and follow the curve of the hips. Notice how the walkie-talkie does not drape to the ground, but instead follows the rise of the hip and buttocks.

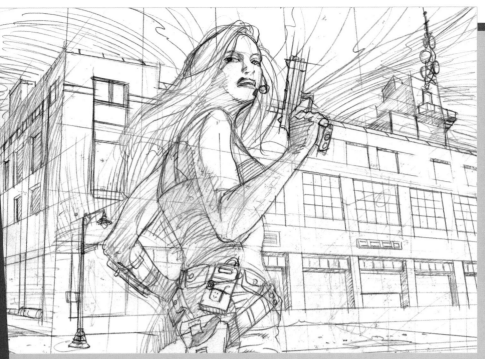

tip

On a pretty female, delineate the nose as little as possible. Keep lines off the face; in fact, let the face get washed out a little, because every line can look like a wrinkle. If you are drawing a young woman, never draw the line that comes from the edge of the nose down to the mouth; that line adds years to a character's appearance.

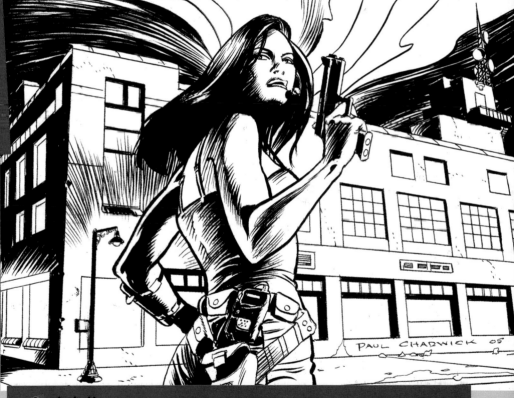

PAUL CHADWICK 05

TECHNIQUE

inking with a brush

Start from the thin end of the line and then thicken it. Practice different motions until you gain the proper brush control. Try inking the stroke toward the base of your hand rather than away from it; working in this direction may give you greater control.

Ink It

4 Artists who ink their own work can be loose with their pencils. Here, I went from loose, fluid pencils right into the final art. Use a brush to get a nice line shape and curve. (See TECHNIQUE at left.)

Notice how a few bold brushstrokes make the sky look imposing and dark. The character now has an eerie moonlit appearance, while the background seems foreboding. A few well-placed ink strokes on the figure show the direction of the light, which comes from the upper right. Also add small details to the background, such as cracks in the concrete. Beat the building up a little with stains and missing chips. These details add to the overall realism and mood without distracting the reader.

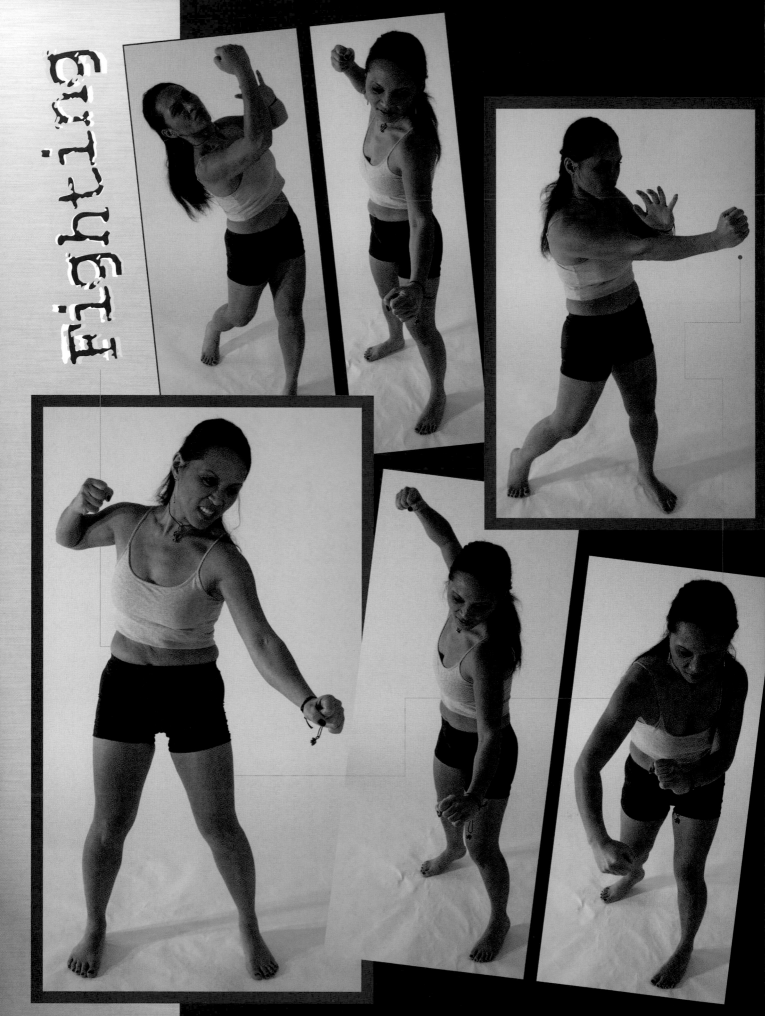

Fighting

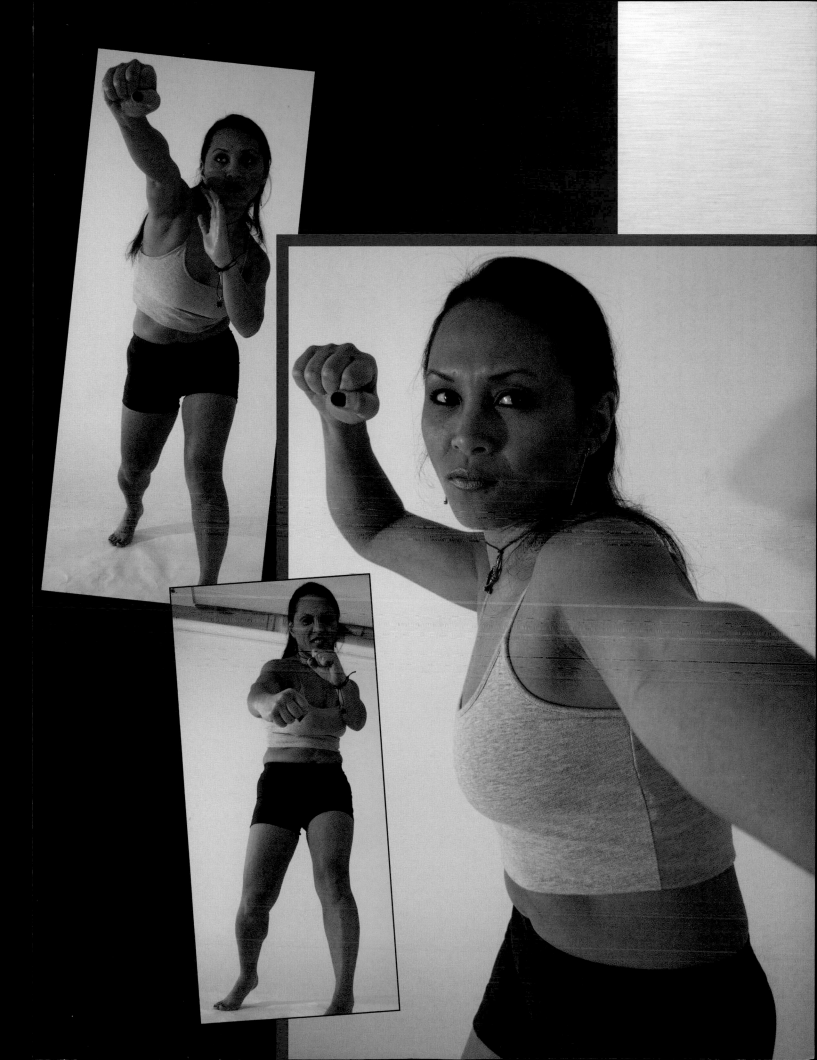

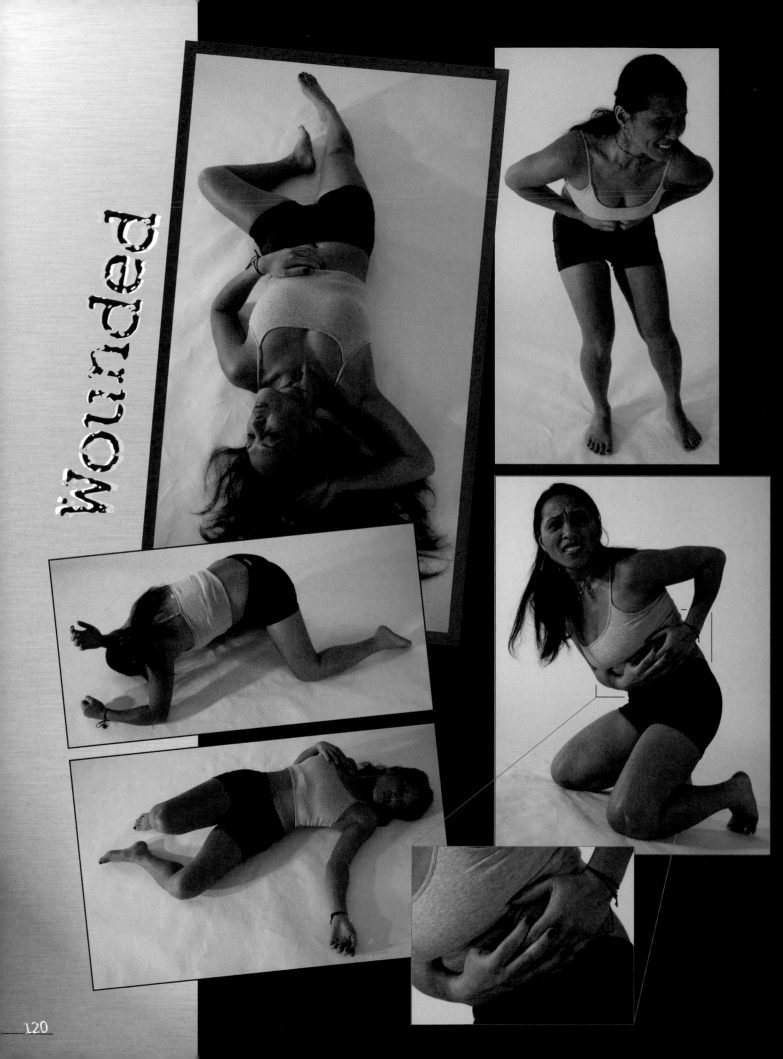

Wounded

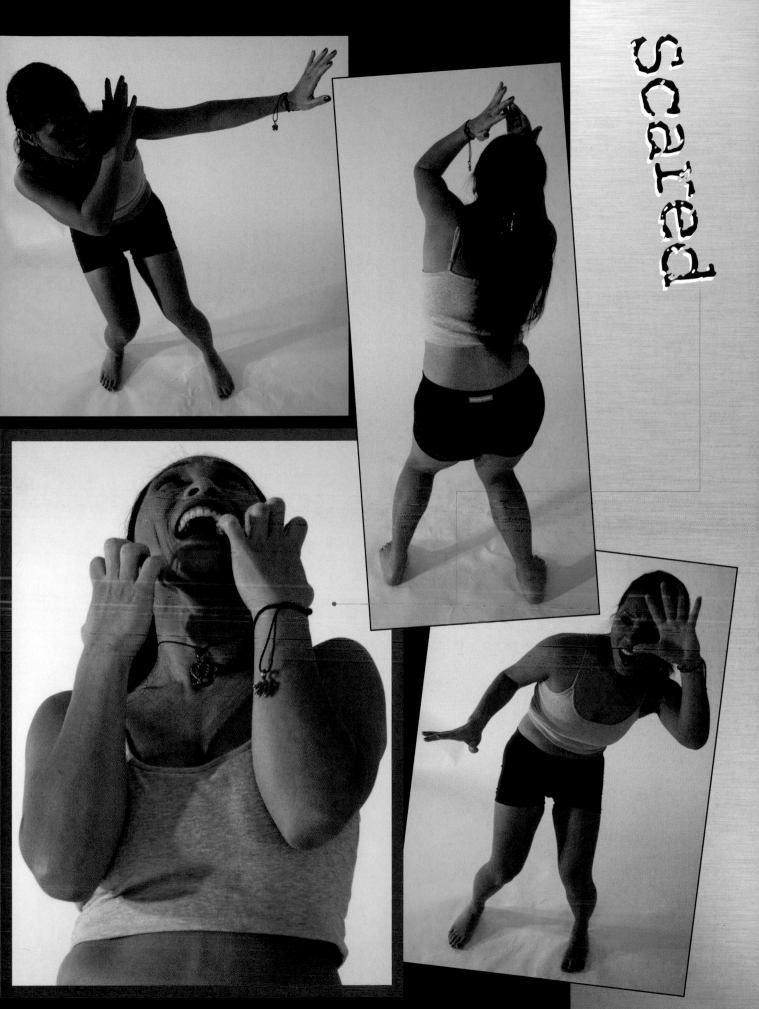

Demonstration

Use Photo Reference to Create a Cartoonish Figure

BY FERNANDO RUIZ

Reference photos are a great resource. Use them anytime you have a shot that you can't readily envision in your mind's eye. Don't be afraid to put a visual in front of yourself.

It's perfectly acceptable to combine references. A single shot may not have all the answers you're looking for. Plus, it's always a good idea to be as visually familiar with your subject as possible. Multiple photos of the same model help you understand how that person moves and exists in the real world.

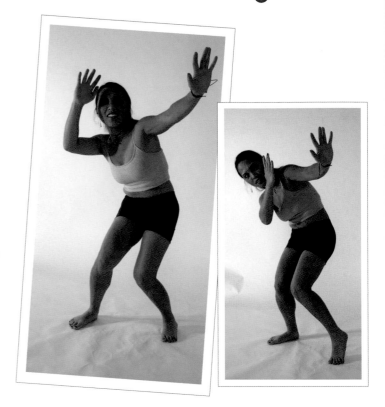

Find Your Photos

In the photo at the left above, the position of the model's torso and the up-shot on her face are very interesting. (Let's face it, up-shots can be difficult. We're not used to looking at people from underneath their jaws.) The lower body on this picture is a bit too animated, though—we're drawing an ordinary girl here, so she's not supposed to look as agile as Spider-Man. The slight foreshortening on the legs and arms in the other photo is really cool. Like up-shots, foreshortening is one of those aspects of art that will look glaringly wrong if not done exactly right. Use reference to gauge yourself and make sure you're doing it properly.

Rough It

Now let's get to the actual drawing. Start with a piece of white two-ply bristol board and a 0.3mm mechanical pencil with an HB lead. This thin, medium-density lead will give you a fine, light line for the initial stage of the drawing—the underdrawing.

Very lightly sketch the critical gesture lines that dictate the pose: the shoulder line, the spine line and the hip line. Add lines that follow the movements of the limbs. Create a face grid showing the center line of the face and the levels of the eyes, nose and mouth. All of this is the raw armature upon which you'll build the figure.

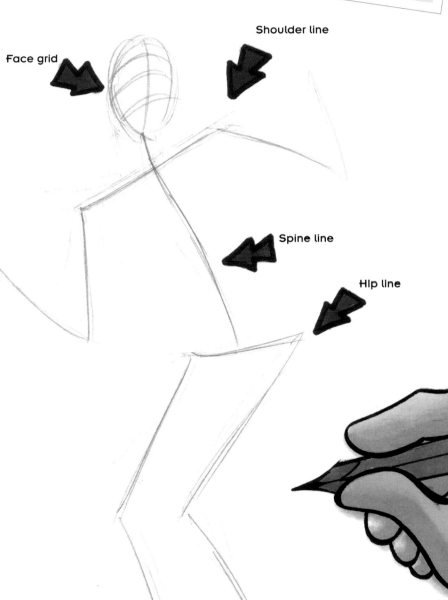

tip
Lots of artists use the "gesture line" concept to get their drawings started. In addition to the rough on this page, check out these other examples:
- "Throw Off the Balance," page 9
- "Gesture Line," page 65
- "Sketch Broadly," page 87

The sketching styles are different, but a gesture line is at the heart of all of them.

Face grid

Shoulder line

Spine line

Hip line

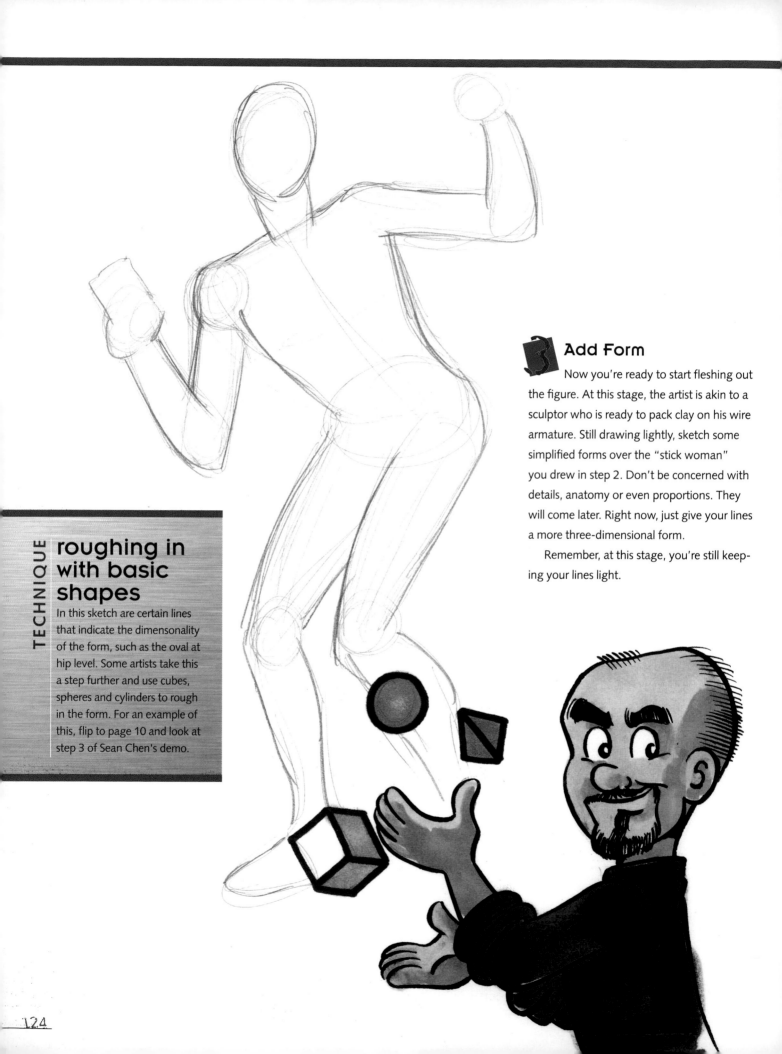

3 Add Form

Now you're ready to start fleshing out the figure. At this stage, the artist is akin to a sculptor who is ready to pack clay on his wire armature. Still drawing lightly, sketch some simplified forms over the "stick woman" you drew in step 2. Don't be concerned with details, anatomy or even proportions. They will come later. Right now, just give your lines a more three-dimensional form.

Remember, at this stage, you're still keeping your lines light.

TECHNIQUE

roughing in with basic shapes

In this sketch are certain lines that indicate the dimensonality of the form, such as the oval at hip level. Some artists take this a step further and use cubes, spheres and cylinders to rough in the form. For an example of this, flip to page 10 and look at step 3 of Sean Chen's demo.

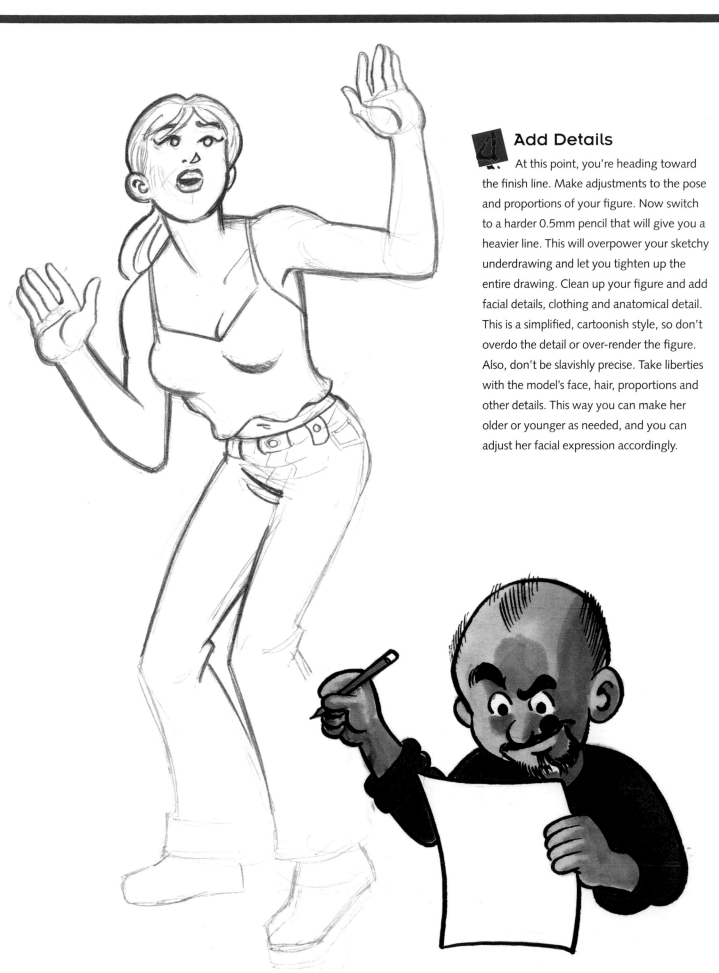

Add Details

At this point, you're heading toward the finish line. Make adjustments to the pose and proportions of your figure. Now switch to a harder 0.5mm pencil that will give you a heavier line. This will overpower your sketchy underdrawing and let you tighten up the entire drawing. Clean up your figure and add facial details, clothing and anatomical detail. This is a simplified, cartoonish style, so don't overdo the detail or over-render the figure. Also, don't be slavishly precise. Take liberties with the model's face, hair, proportions and other details. This way you can make her older or younger as needed, and you can adjust her facial expression accordingly.

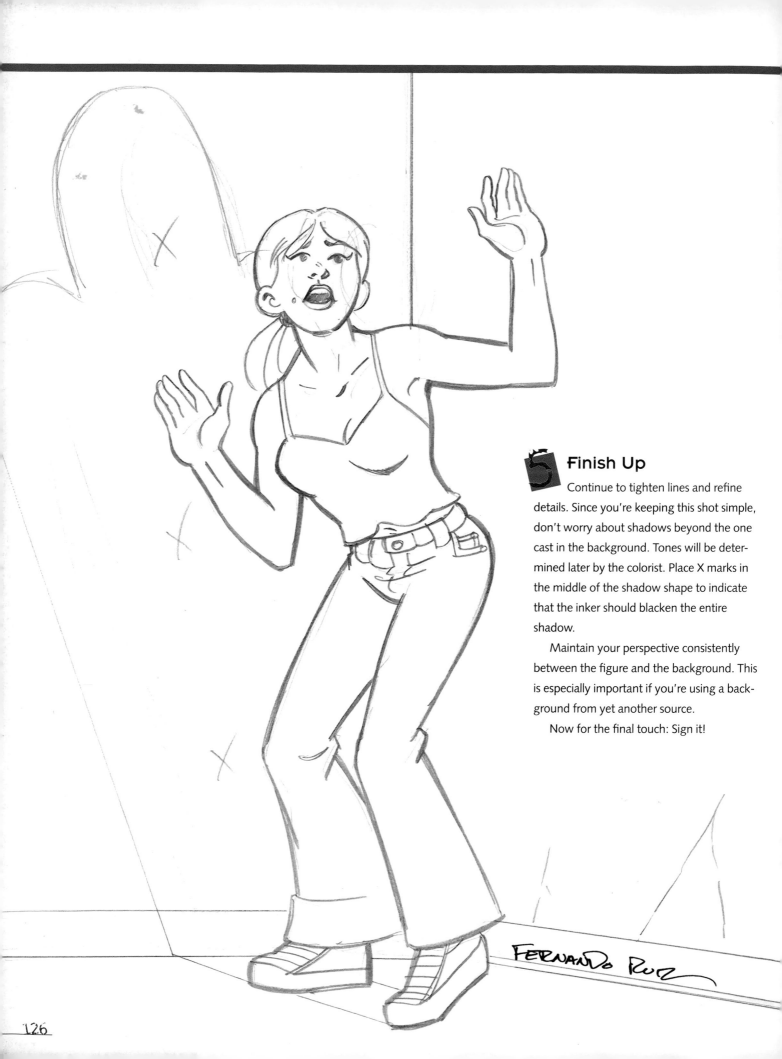

Finish Up

Continue to tighten lines and refine details. Since you're keeping this shot simple, don't worry about shadows beyond the one cast in the background. Tones will be determined later by the colorist. Place X marks in the middle of the shadow shape to indicate that the inker should blacken the entire shadow.

Maintain your perspective consistently between the figure and the background. This is especially important if you're using a background from yet another source.

Now for the final touch: Sign it!

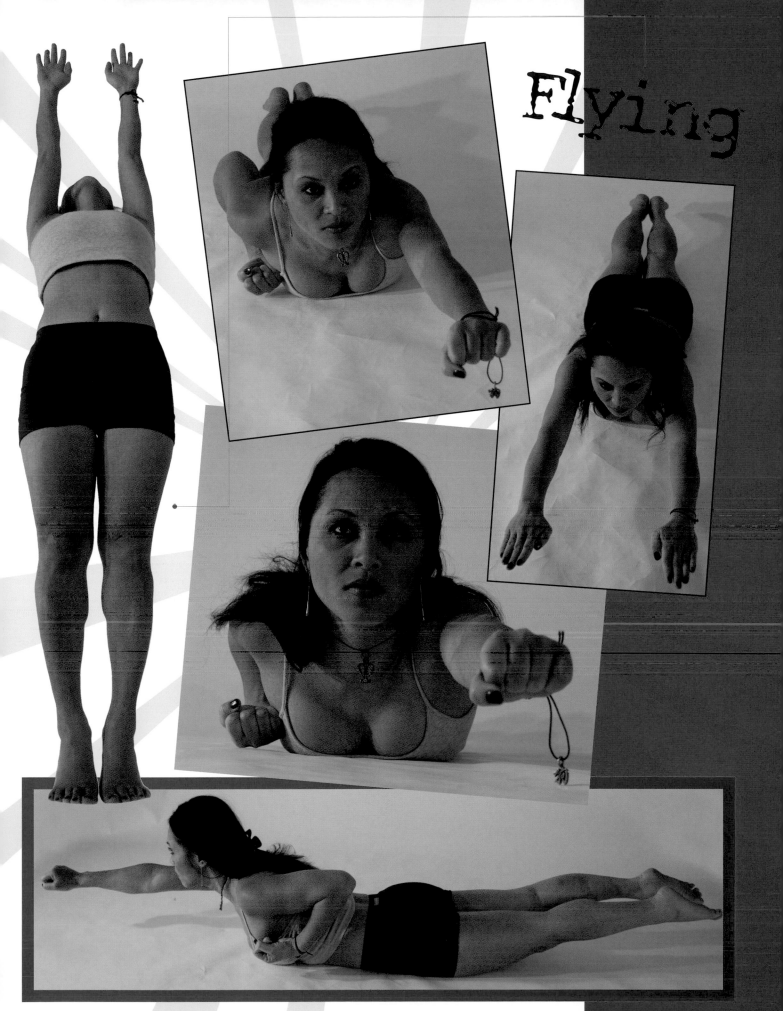

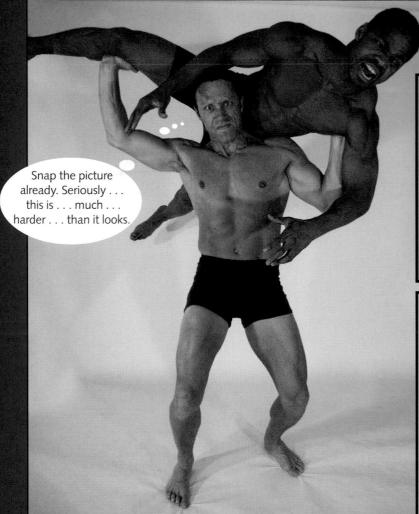

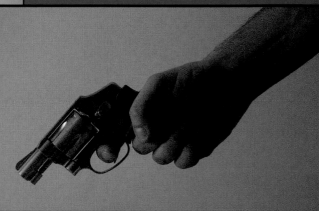

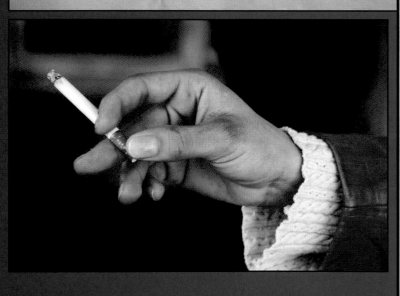

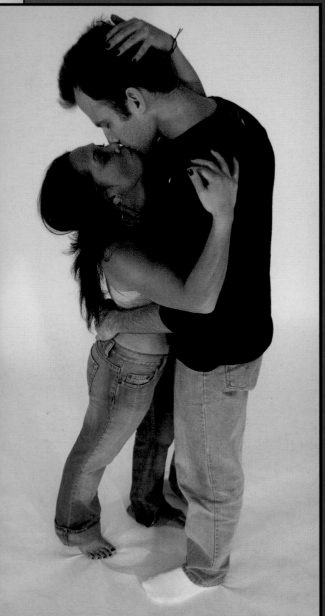

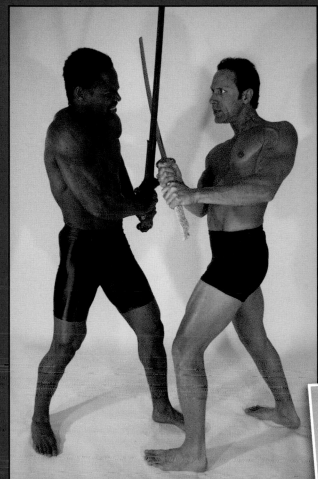

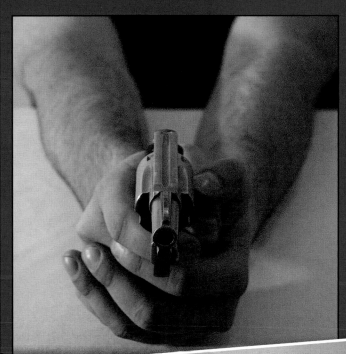

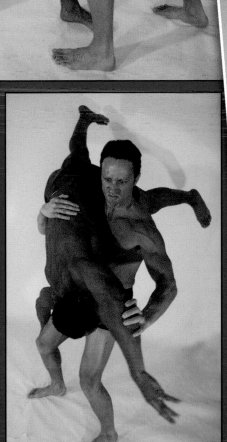

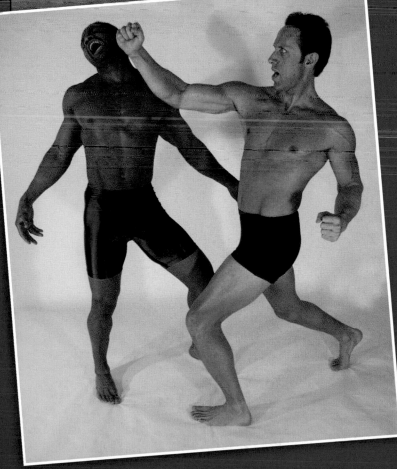

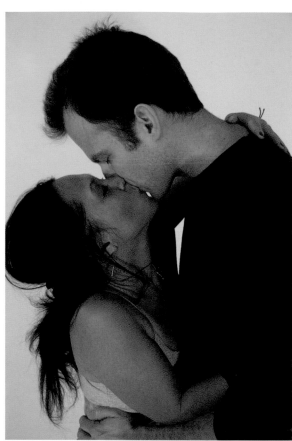

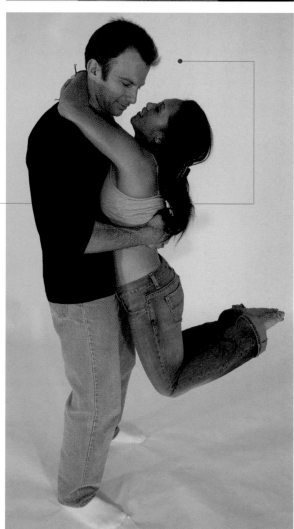

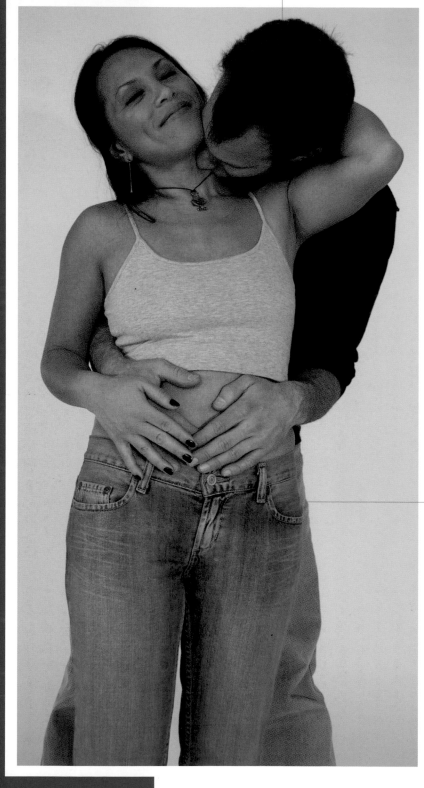

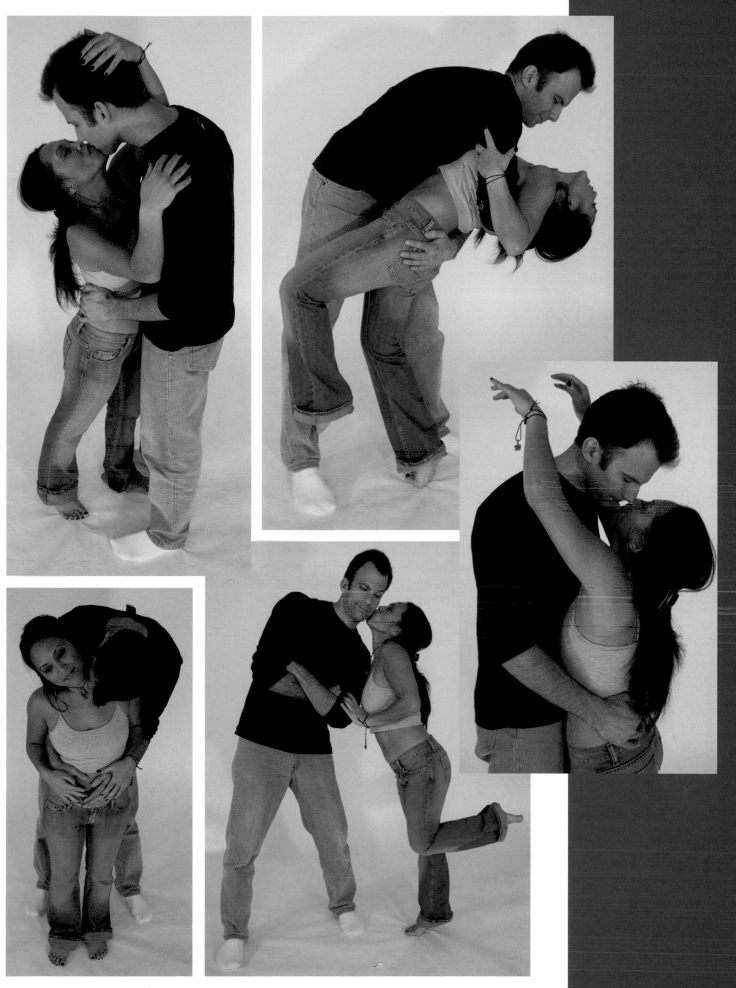

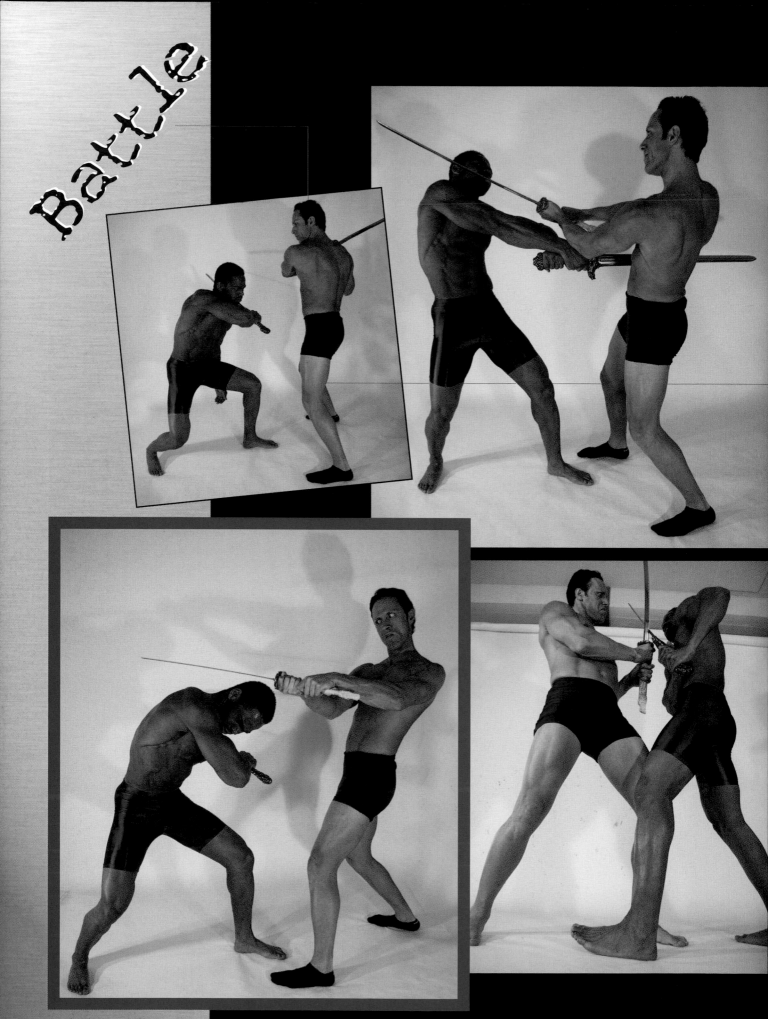

Battle

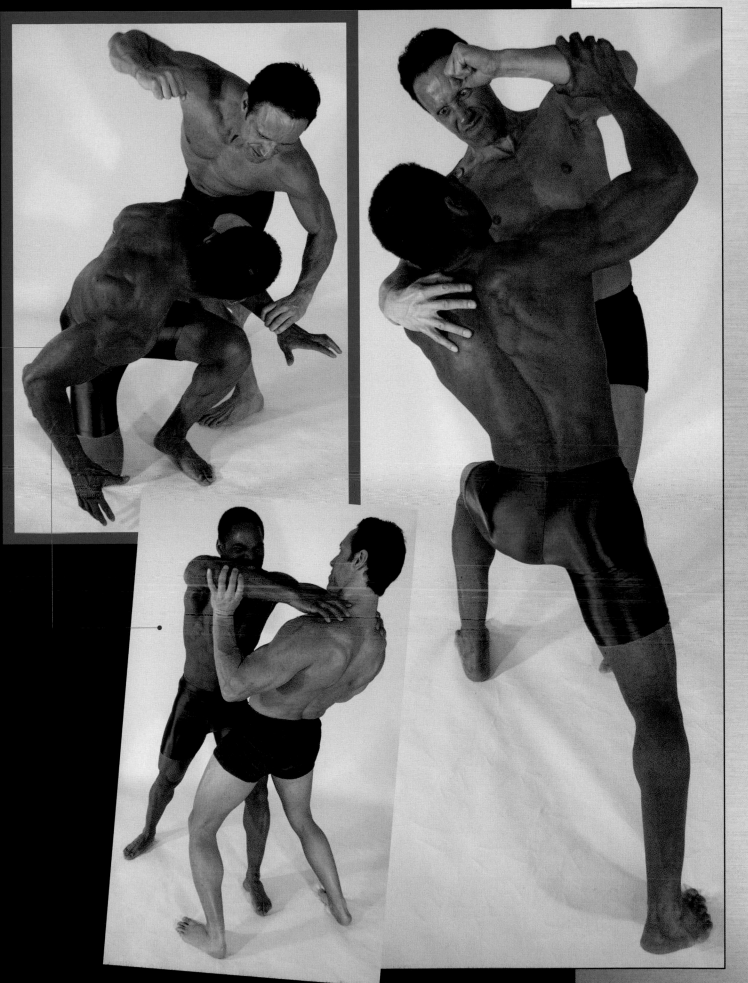

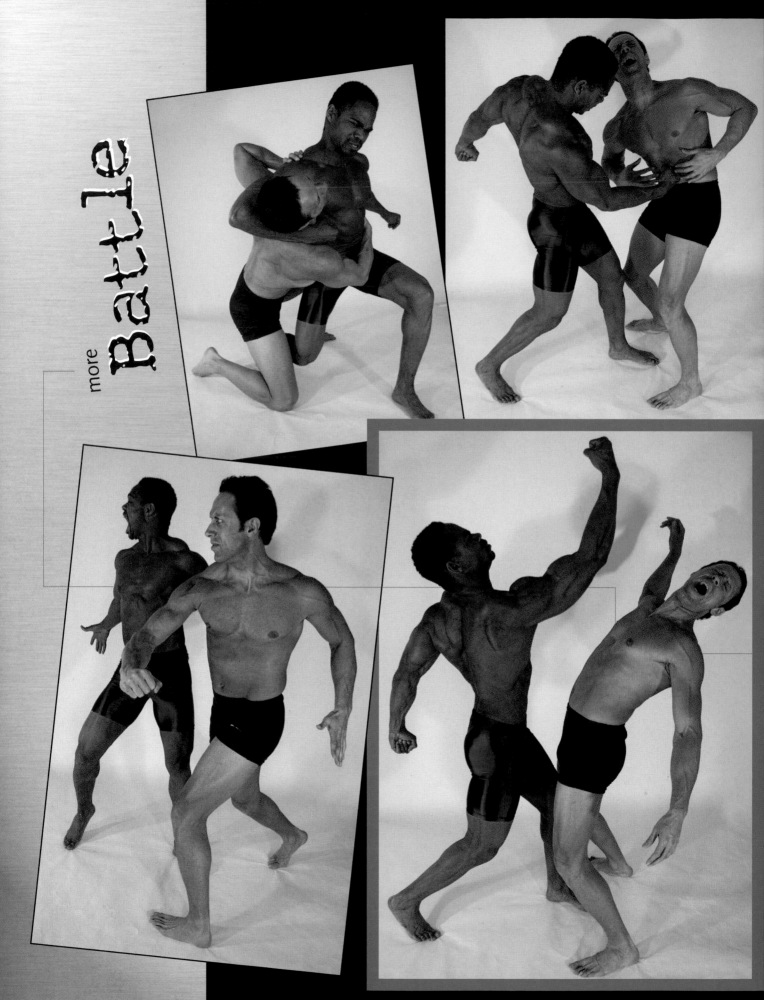

more *Battle*

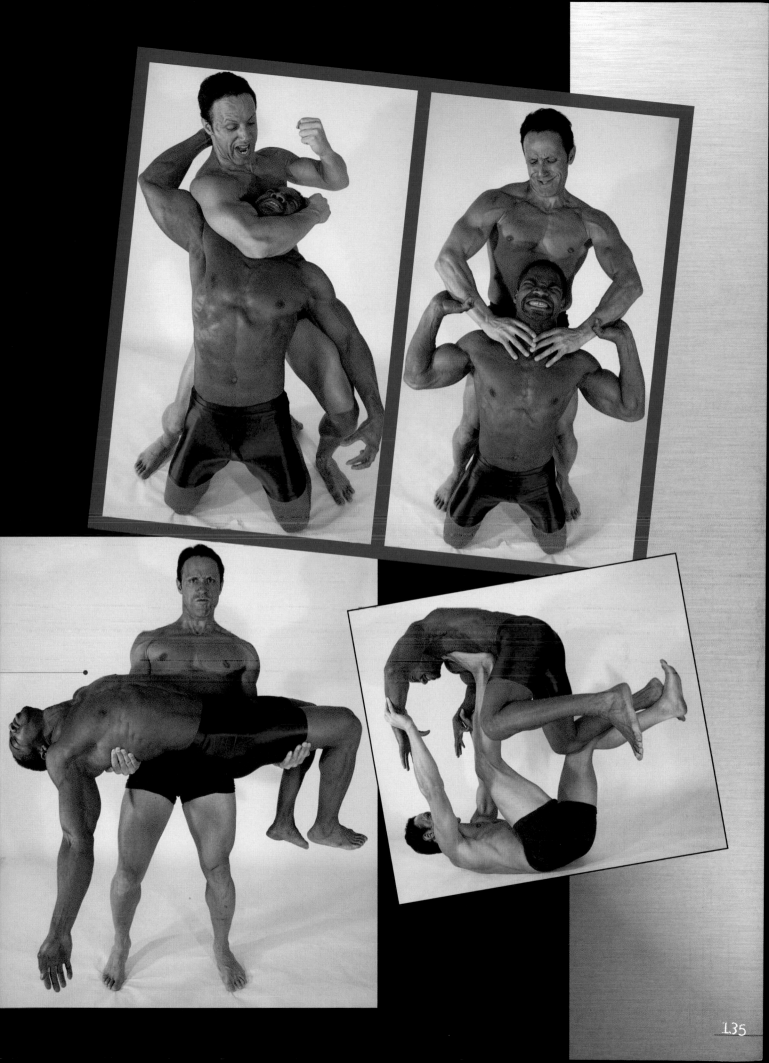

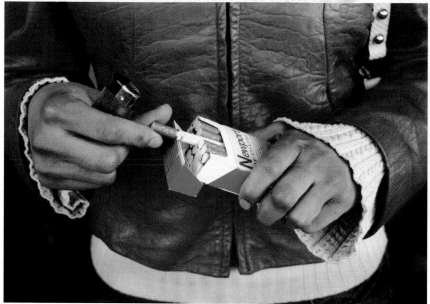

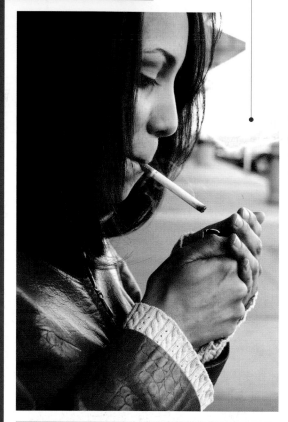

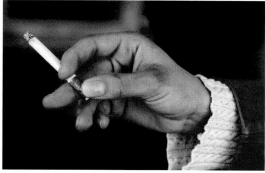

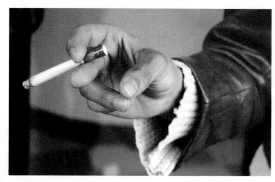

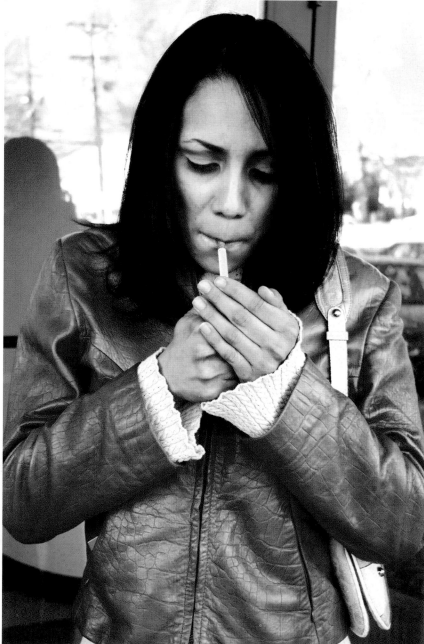

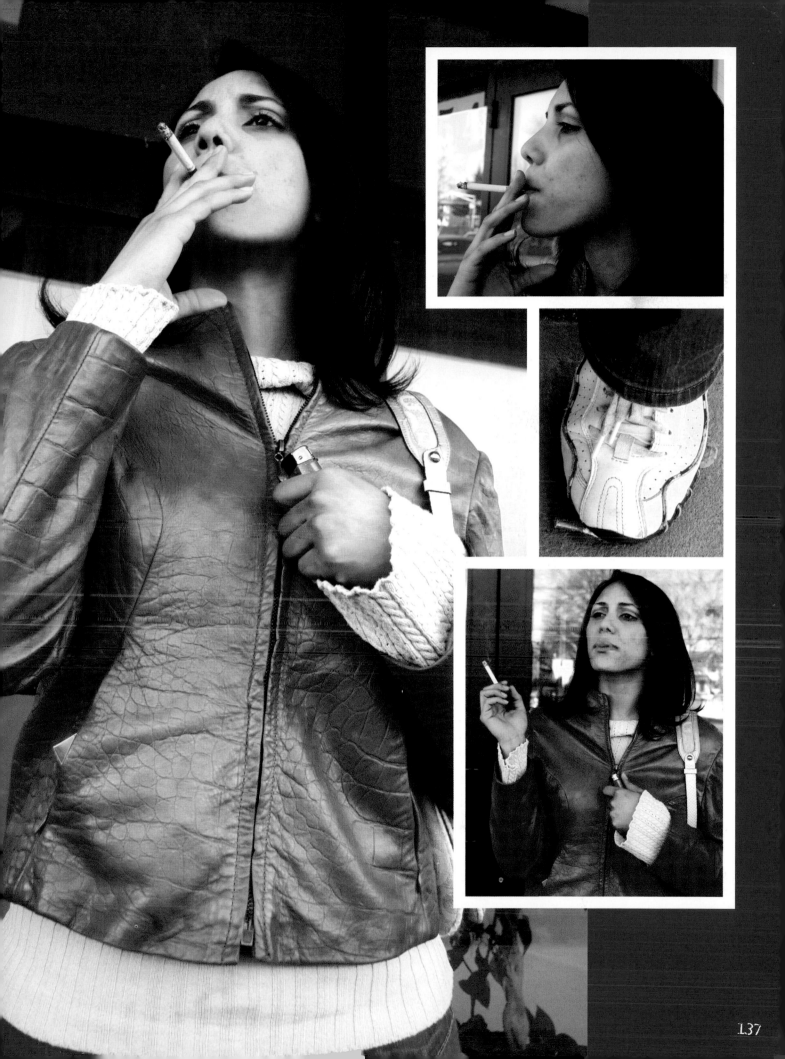

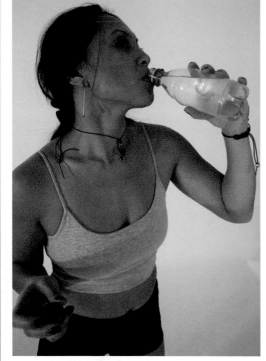

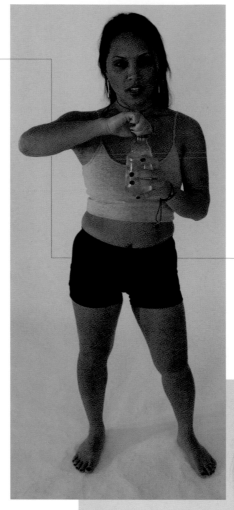

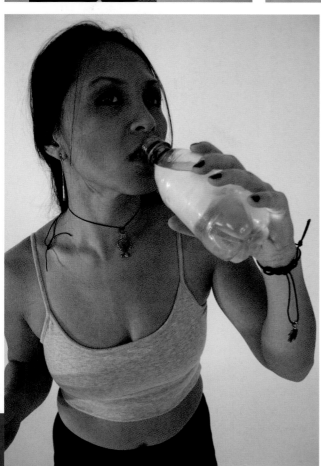

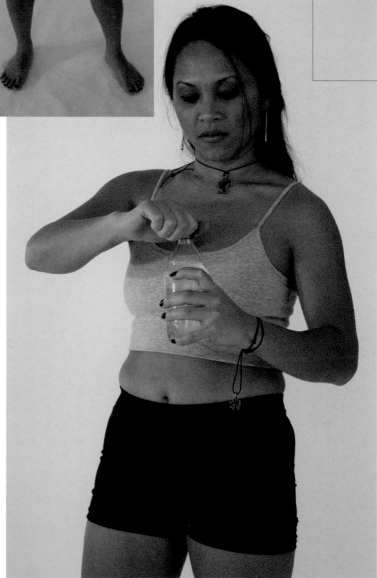

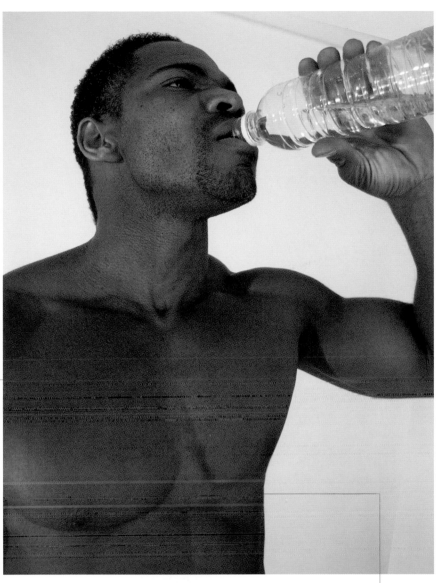

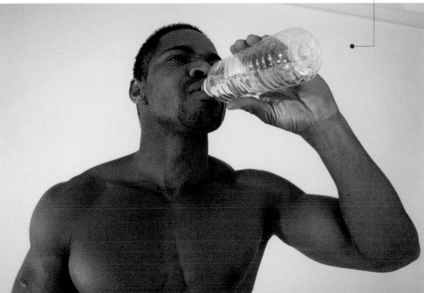

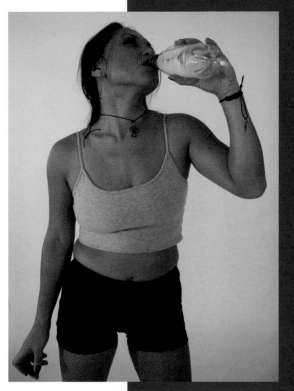

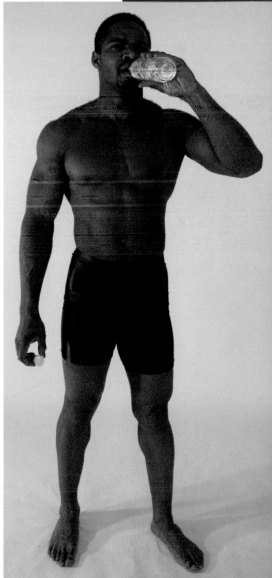

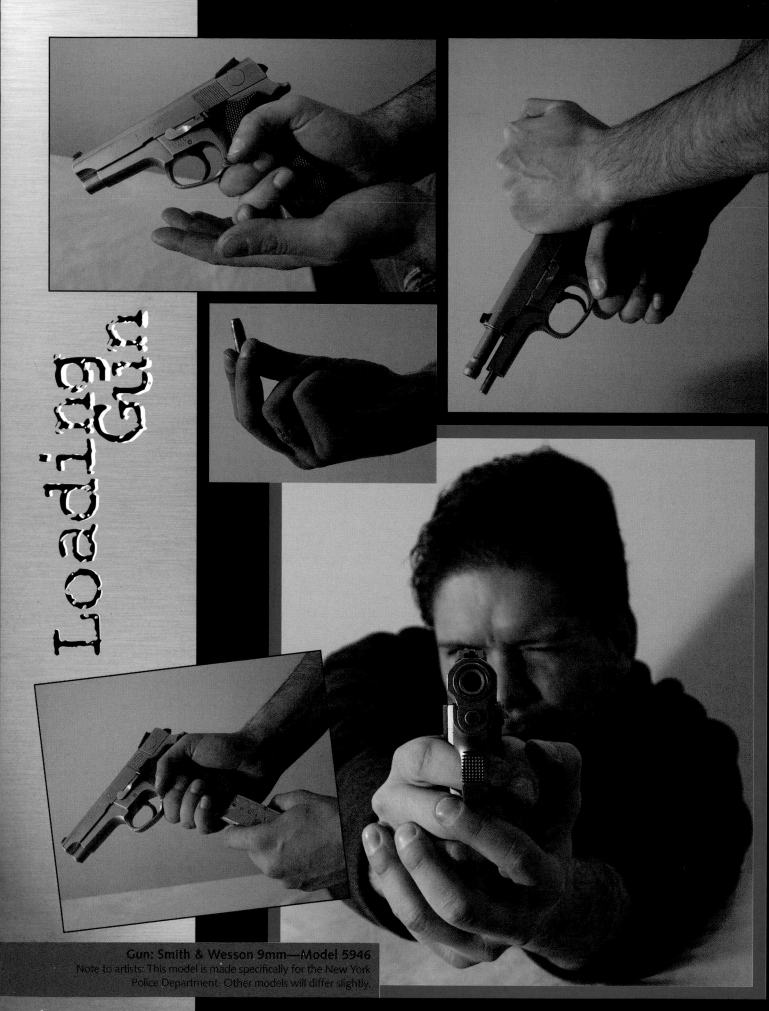

Loading Gun

Gun: Smith & Wesson 9mm—Model 5946
Note to artists: This model is made specifically for the New York Police Department. Other models will differ slightly.